# BEHIND THE MASK

The NHS family and the fight with COVID-19 by Glenn Dene

Words by Dr Ami Jones, and contributions from
Michael Sheen, Jamie Roberts, Aneira Thomas
and the staff of Nevill Hall Hospital.

GRAFFEG

# Introduction by Jamie Roberts

What has been most fascinating during the past few months is how the healthcare service has had to adapt in the face of the current pandemic. Due to the nature of a novel respiratory virus, it's had to transform not just quickly, but also become more efficient in its operation and healthcare delivery. Many processes that would have taken years have been undertaken in weeks.

We all face pressures of different kinds each and every day. Family pressures, financial and social pressures to name a few. Yet the immediate pressure on our own and collective health, the most important source of wealth to us all, has driven individuals inside and outside the health service to elicit change unlike anything in modern history. Having had to return from playing rugby in South Africa due to the pandemic, I offered my services as a volunteer to the Cardiff & Vale University Health Board. I've had the privilege to witness first hand some of the changes that have occurred not just in frontline healthcare on wards and in hospitals but also in community and office settings. Many of these changes have been

We are witnessing an enforced streamlining of services that will arguably ensure healthcare provision continues to a higher standard than it was before.

enforced in order to manage the Coronavirus and it's fair to say many will not revert back.

We are witnessing an enforced streamlining of services that will arguably ensure healthcare provision continues to a higher standard than it was before. Many of these changes revolve around the centralization of healthcare resources as teams are having to work collaboratively more than ever before. Out of the crisis has come the opportunity to utilize communication technology more than ever before. These changes are likely to transform healthcare provision for good and place the scope for innovation and opportunity within the healthcare climate on to a whole new trajectory. I've had the opportunity to document these changes through writing a blog, yet Glenn has brilliantly captured this crisis through the lens of his camera. I'm sure this book of images will tell not only of the tragedy of the Coronavirus crisis, but the transformation and opportunity it brought with it.

**Dr Jamie Roberts**
Wales international rugby player.

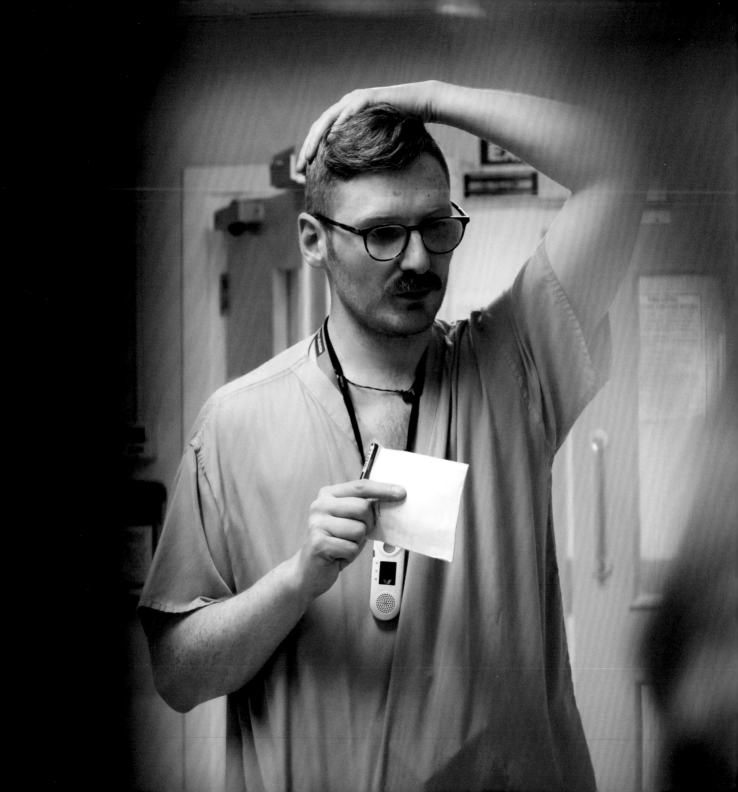

# The Unwanted Arrival

We were told by Public Health Wales to expect hundreds of patients and to increase our intensive care capacity, potentially by up to ten times the usual amount.

In March 2020 our district general hospital, nestled amongst the three peaks of Abergavenny, began to prepare for the unwanted arrival of Novel Coronavirus, also known as COVID-19. We were told by Public Health Wales to expect hundreds of patients and that we needed to increase our intensive care capacity, potentially by up to ten times the usual amount. What followed, during what is widely anticipated to have been a first wave of infection, was two months of resolute clinical care for the beloved population we serve. What also took place was an intense bonding of our hospital staff in a way none of us had ever experienced before. Hopefully the words that follow will offer you a small glimpse into the world of our intensive care unit, and the people who continue to serve 'behind the mask.'

Intensive care is where the sickest patients in the hospital come to receive support for failing organs. Treatment usually involves giving assistance to lungs, kidneys or heart by machines and drugs; all of which is aimed at buying time for patients to get better from whatever is acutely wrong with them. This might be an infection, getting over a big operation or recovering from a serious trauma or cardiac arrest. It is called intensive care as the ratio of nurses and doctors to patients is much higher than on a normal hospital ward.

A very sick patient on a ventilator and kidney machine will be nursed by their own nurse twenty-four hours a day and will be reviewed by doctors numerous times day and night. Unsurprisingly, these patients are the sickest of the sick and, despite our best efforts, in usual times we are often unable to save around 20% of those we treat.

What was about to happen to the world due to COVID-19 was nothing like usual times…

We were told that many of these patients would be young, many younger than most of our staff, and that they would be sick in a way that we had never seen the like of before. We were also told that, however hard we tried, of those who ended up needing us, we would only be able to save around half of them.

We only had a small eight-bed intensive therapy unit (ITU) which would certainly not be enough for the tidal wave of sick young patients we were warned was heading our way. We also only had enough staff and equipment to look after eight sick patients at one time.

Due to the predictions of many more critically ill patients than we would usually have beds for, staff were moved and retrained so they could help look after the sickest. New drills were practised over and over; namely donning (putting on) and doffing (taking off) personal and protective equipment (PPE), a task which would soon become sadly familiar to all of us and a way of life for several months to come. But our lives quite literally depended on us getting it right, else we might risk contracting the infection ourselves.

The hospital moved swiftly. Wards were re-organised and spaces identified that could be turned into new ITUs. The hospital was divided into areas where COVID patients could be treated and areas where other patients would continue to receive medical care. Despite elective operations and routine clinic appointments being cancelled and COVID seeming to be all-encompassing, people were still going to need emergency surgery and women still had babies to deliver.

The hospital moved swiftly. Wards were re-organised and spaces identified that could be turned into new ITUs.

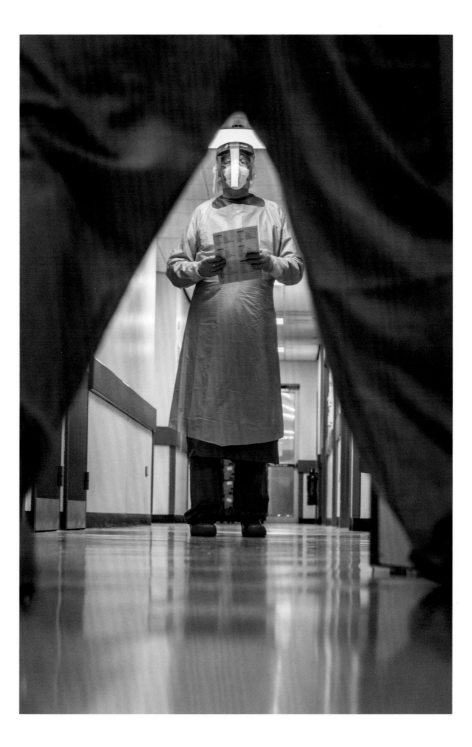

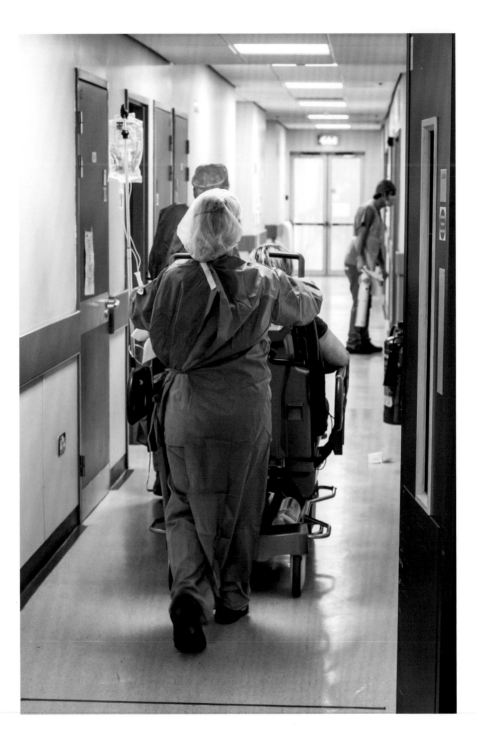

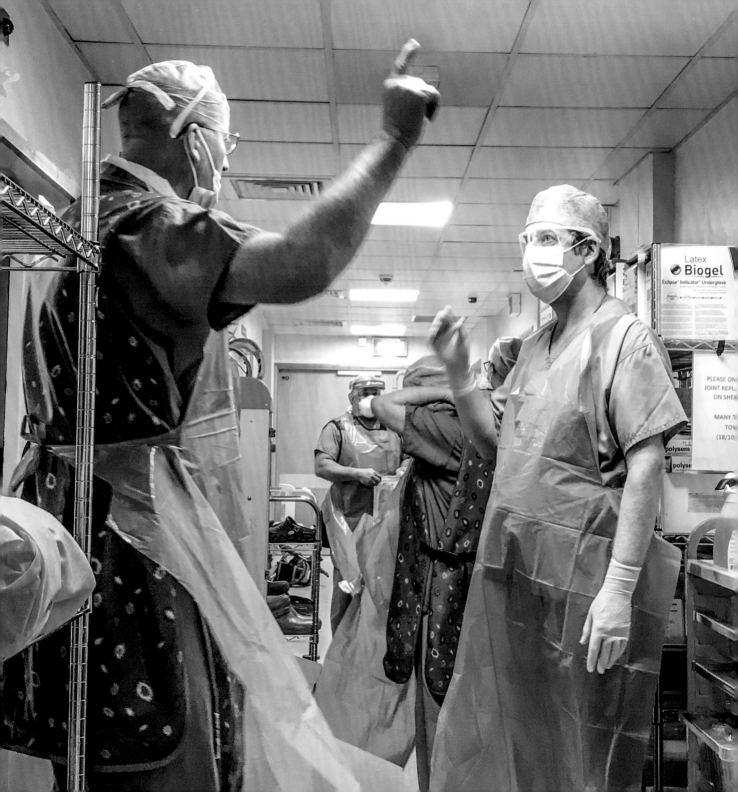

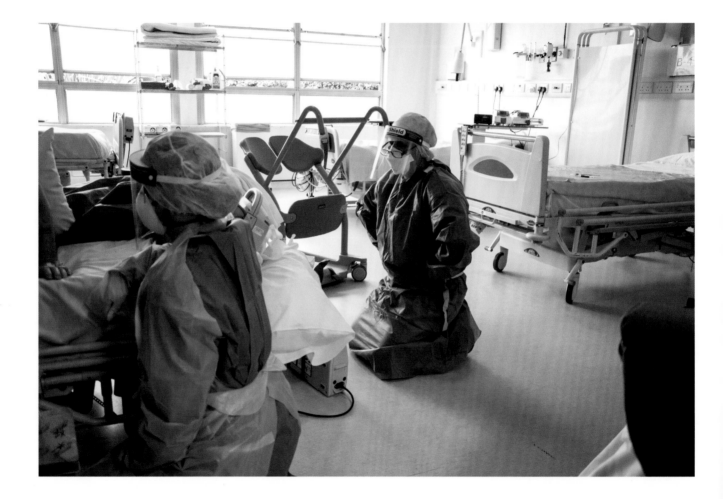

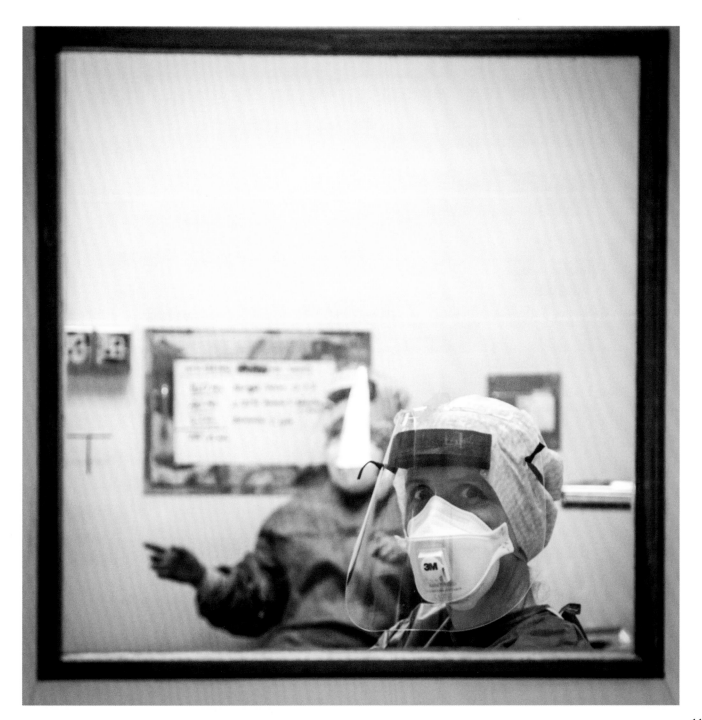

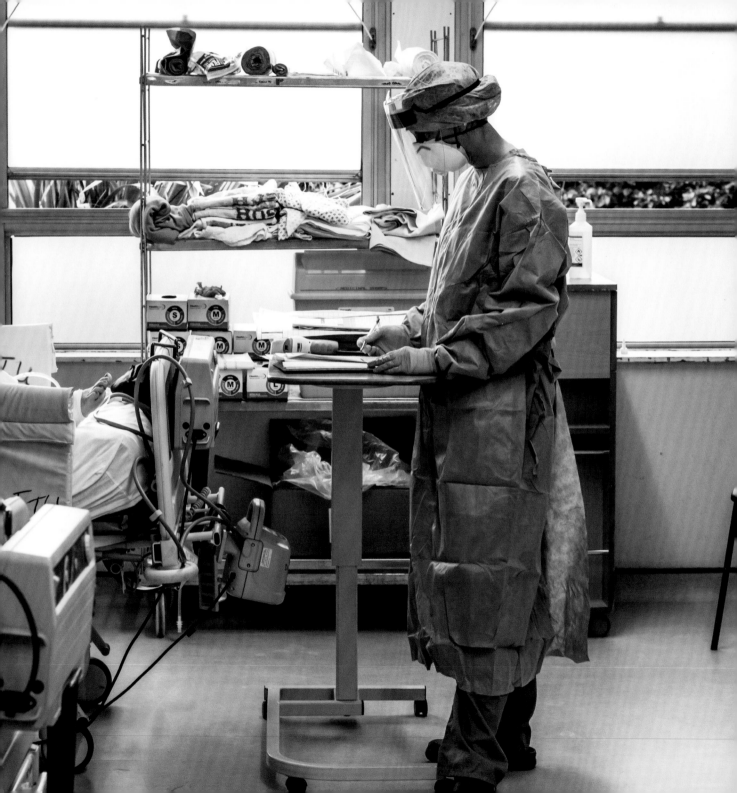

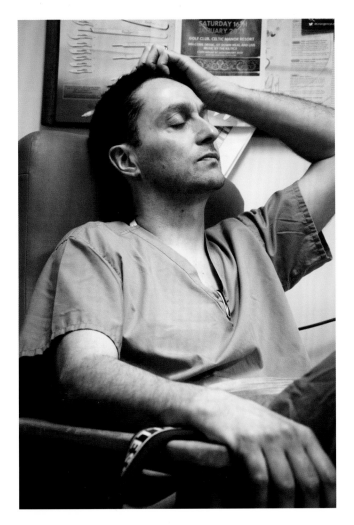

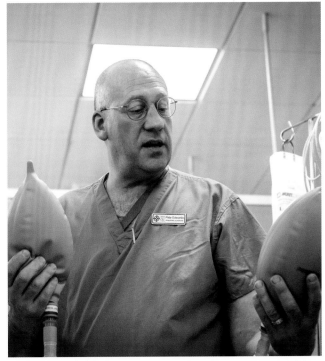

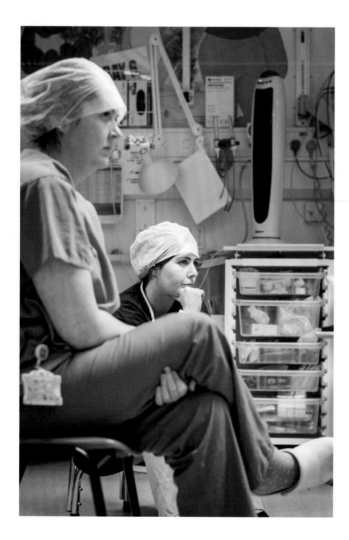

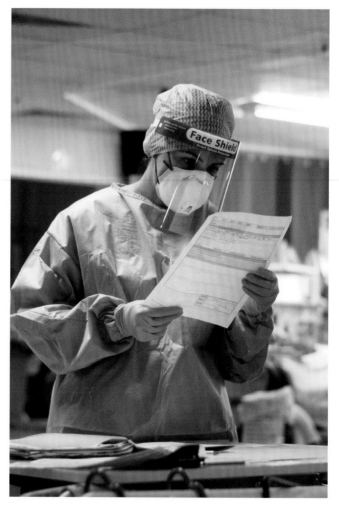

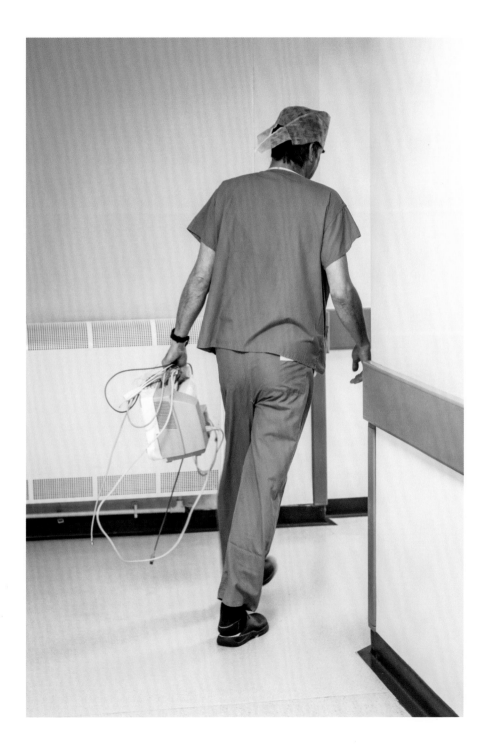

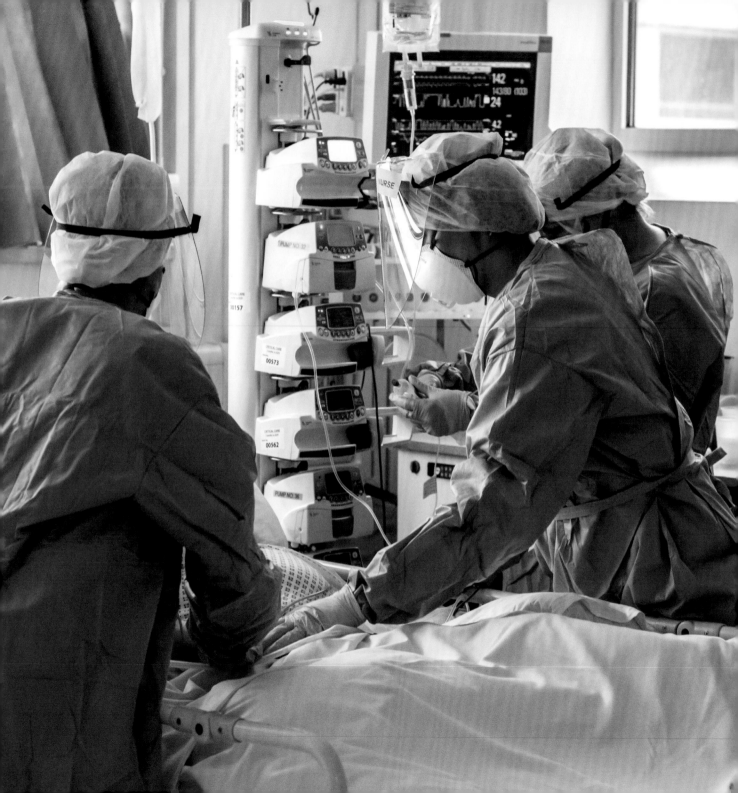

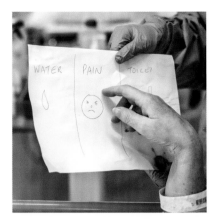

'The teamwork in ITU has made this one of the best experiences in the worst situation.
I will always love my ITU family.'

Laura Bumpstead, Resuscitation/Outreach Practitioner.

## And after all of that planning and drilling, and preparing, we waited.

So a degree of 'business-as-usual' had to be catered for, albeit in a new manner with swathes of PPE being worn to keep everyone safe. This meant that quite a straightforward and quick procedure would take three times longer than usual and that staff were going to have to do already quite stressful procedures in hot and uncomfortable PPE.

And after all of that planning and drilling, and preparing, we waited.

It felt like the videos you see of what happens just before a tsunami hits; when the tide goes out, the sea disappears and everything goes eerily quiet. The public were on lockdown and, although we'd had a trickle of patients enter the hospital, with elective operating ceased and most people 'scared' to attend, the hospital entered a rare phase of quiet and calm. We wondered if the wave would ever hit us? We didn't want it to as we'd seen the pictures from Italy of how badly their hospitals had been smashed, but equally we were poised, trained and ready to give our best if it hit, when it hit.

And it hit.

'31 years ago I started working in theatre.
The virus is indiscriminate, ruthless and silent.
The fear I felt everyday was like a death sentence.
I sat with my 21 year old daughter one morning
and she asked how was I doing. I burst into tears.
And I just didn't know why.'

Ian Brooks, **Operating Department Practitioner.**

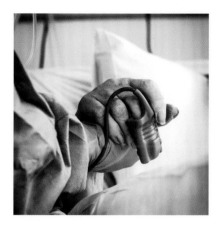

Maybe not quite as Italianesque a scene as some of us had mentally prepared for, but busy enough that on some shifts we went from patient to patient, giving them an anaesthetic, inserting lines into their necks for medication and getting them settled onto ventilators.

This is the part we had been rehearsing for. We knew how to put people asleep and onto a ventilator, that was our day job, but we had to make some tweaks to our practice for these COVID patients and that was one of the things we had been practicing over and over. It was high risk, both for us and them. These patients typically present with amazingly low oxygen levels; some respond well to simple oxygen from a face mask but others don't, and it's those patients who require what we call 'invasive ventilation'; that is, under anaesthetic to have a plastic breathing tube inserted into their windpipe and then have a ventilator fully take over their breathing. Doing this is risky for the patient as we have to give them an anaesthetic drug to render them unconscious, then a muscle relaxant so the muscles in their voice box don't resist us passing the tube into their windpipe. This can affect their oxygen levels and their blood pressure if it's not done with the greatest of care.

**We knew how to put people asleep and onto a ventilator, that was our day job, but we had to make some tweaks to our practice for these COVID patients.**

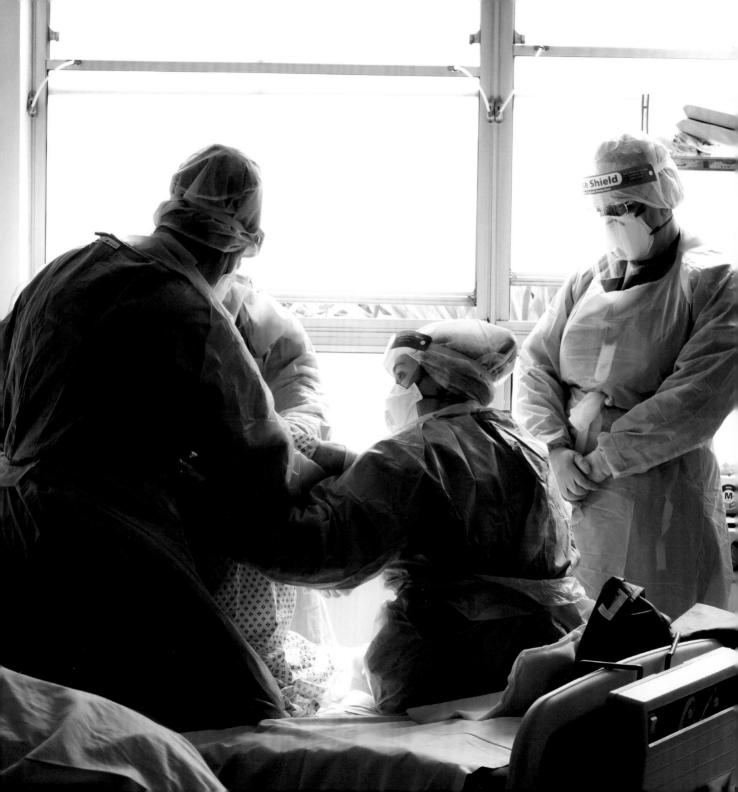

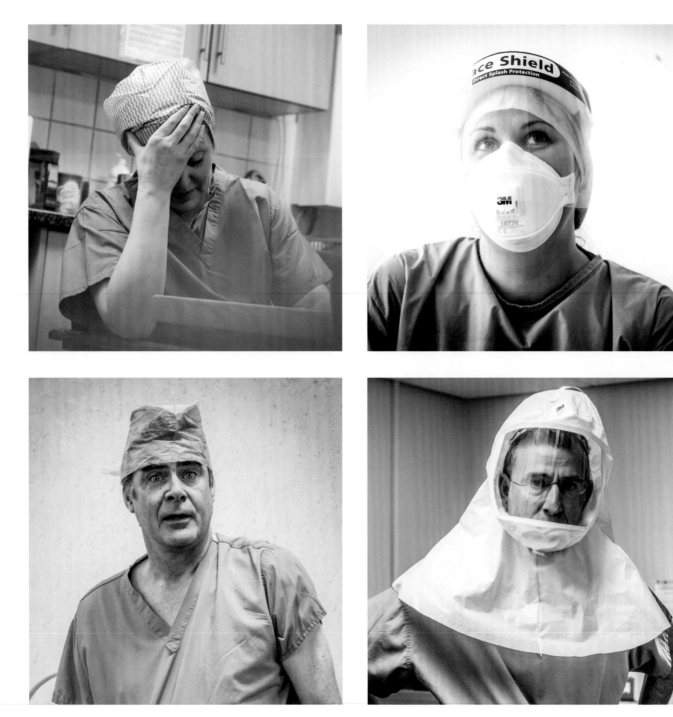

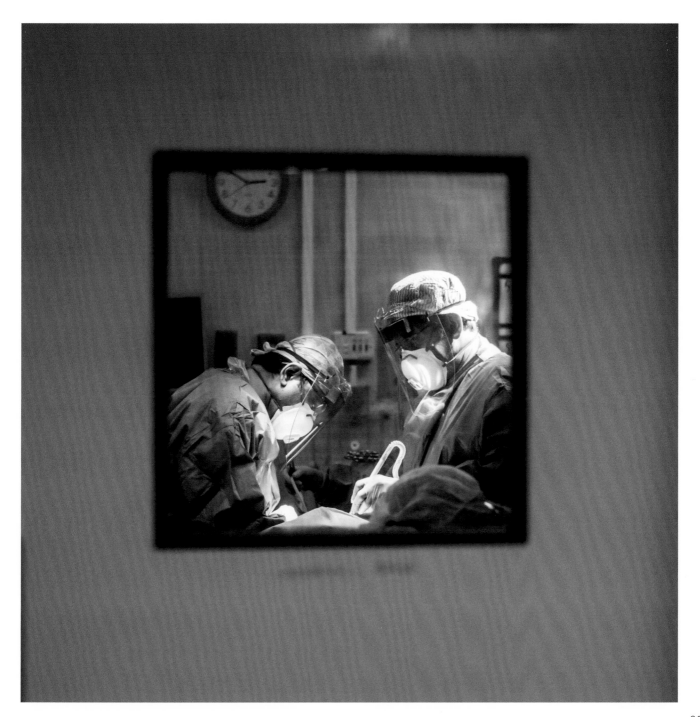

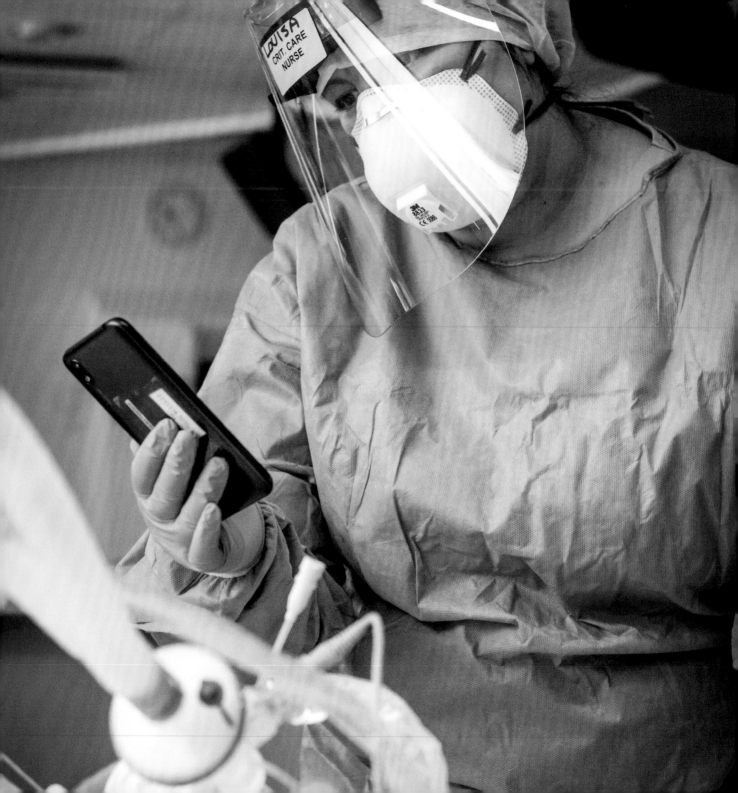

**What was odd about most of these patients was that they were so young and fit compared to our usual ITU population, but we soon learned that no-one is really safe from COVID.**

And the risk to the clinical team? Well, this procedure generates aerosol which is full of viral particles. Everyone in the room must wear the highest level of PPE to protect them from these viral particles; two gowns, two pairs of gloves, a tightly fitted face mask, a hat and a full-face visor. We practiced a special way of doing this procedure to minimise risk, both to us and to the patient, so that we became like a formula one team. Every team member knew their role and was able to perform it with precision.

What was odd about most of these patients was that they were so young and fit compared to our usual ITU population, but we soon learned that no-one is really safe from COVID. They also 'appeared' to be quite well compared to most critically unwell patients; despite their very low oxygen levels they had just enough oxygen around to be perfusing their brain. They were mostly very lucid and often quite rightly scared at the thought of going onto a ventilator, and we always tried to make time for the patient to ring or video-call home and speak to loved ones before we took them to ITU. Sadly, we know that approximately 50% of patients entering ITU due to COVID won't leave it again alive, so a precious few moments for the patient to speak to, or maybe even see, their family was vital if possible.

In fact, mobile phones became something of a lifeline between our patients, their relatives and us as their caregivers. Due to the risk of infection, all visitors were banned from the hospital; we didn't want them to get an infection and equally we didn't want to catch an infection from them.

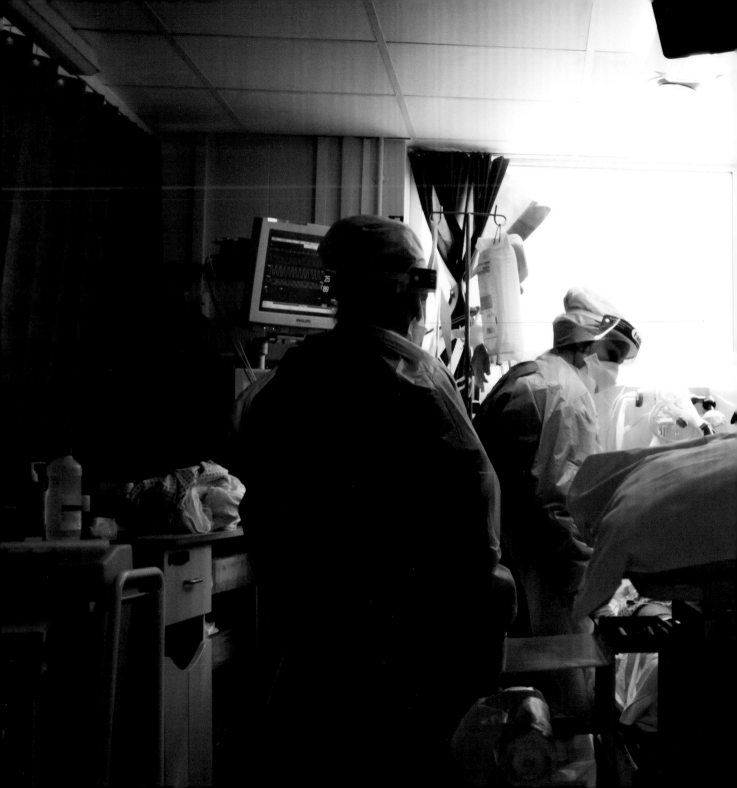

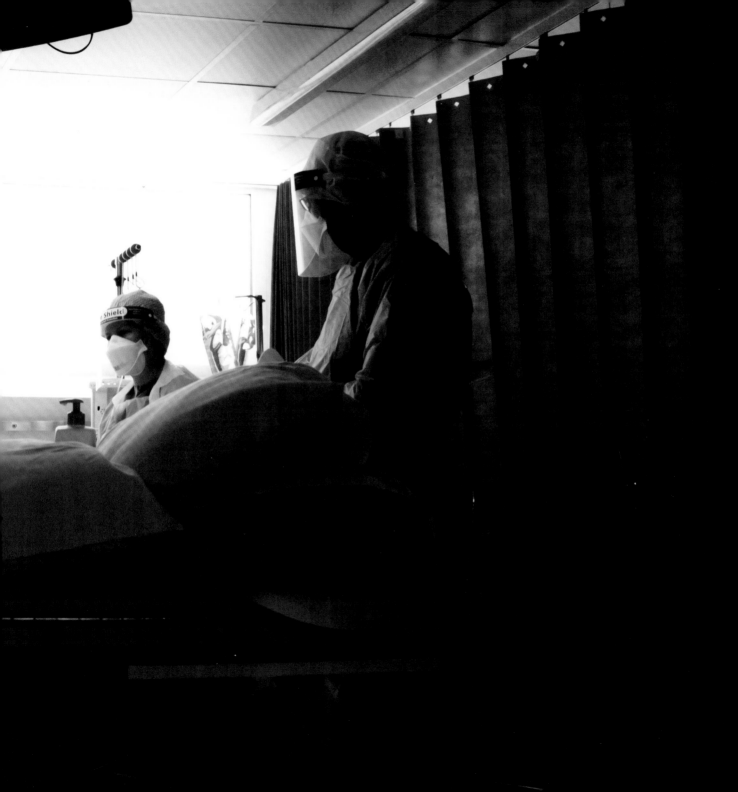

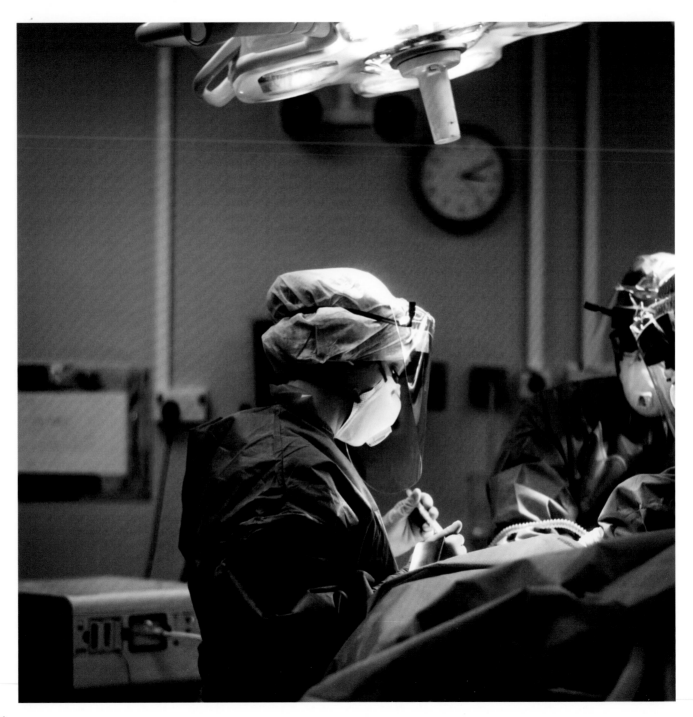

**To tolerate being on a ventilator we have to give patients a series of sedatives which renders them largely unconscious.**

For patients on the wards this was tough; hours and days spent in cubicles with face-masked nurses popping in periodically to do observations and give medications and not much company otherwise. So the ability to call home, maybe even see a friendly face, was a real boost.

For the patients on ITU, once they were 'asleep' and on the ventilator, was this as important? To tolerate being on a ventilator we have to give patients a series of sedatives which renders them largely unconscious, semi-conscious at best. They have a tube between their vocal cords which also prevents them from talking. They will be aware of very little except for maybe mild discomfort when being moved or discomfort from the breathing tube, but they receive medication to help with this too. In normal times when visitors are allowed into hospital, a critically ill patient will be visited frequently by their relatives.

It's important for family to see their sick relative and it's equally important for the ITU doctors and nurses to have opportunities to explain what's happening, what progress is being made and what we think is going to happen. None of these discussions could take place face-to-face now. So we were reliant on video calls to let the relatives see their loved one but, as distressing as you might think it is to see a very sick family member or close friend unconscious on a ventilator, a picture often paints a thousand words; trying to describe what is happening over the phone doesn't come close. There is also something comforting in actually being able to see your loved one.

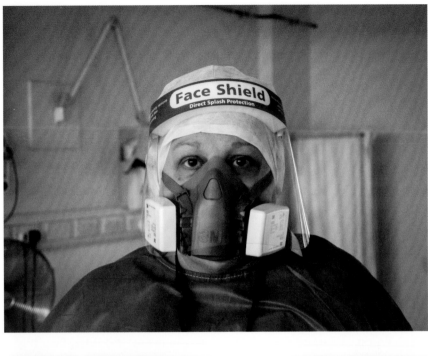

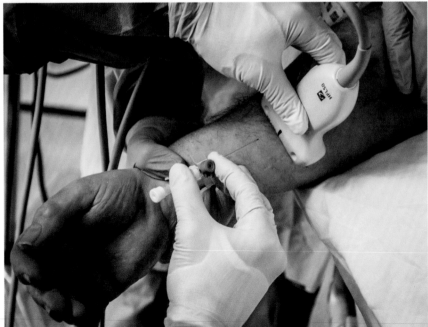

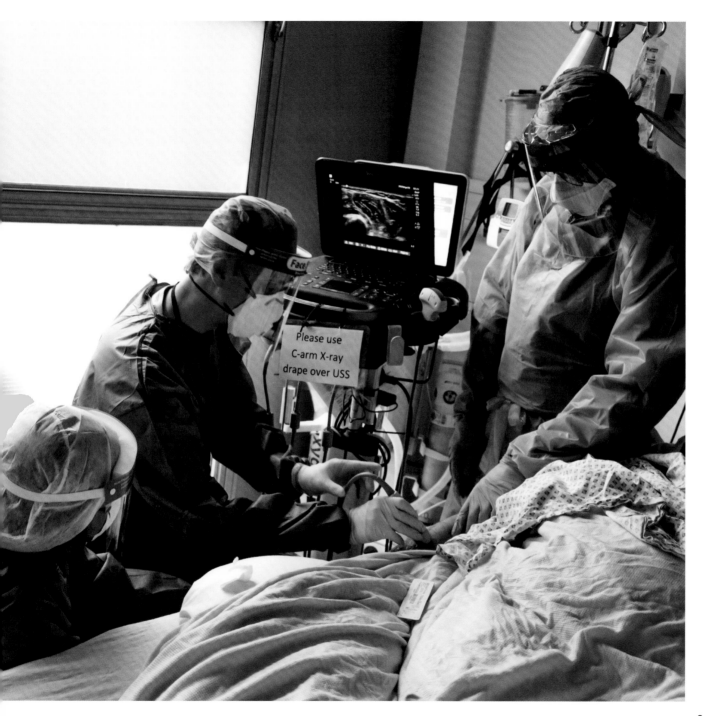

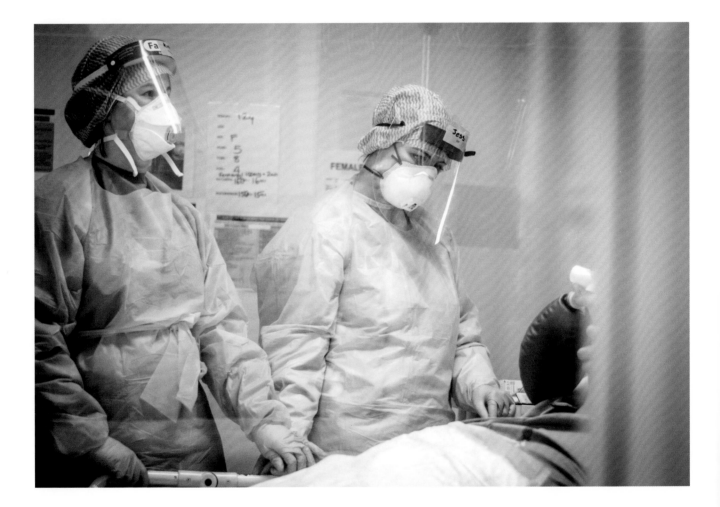

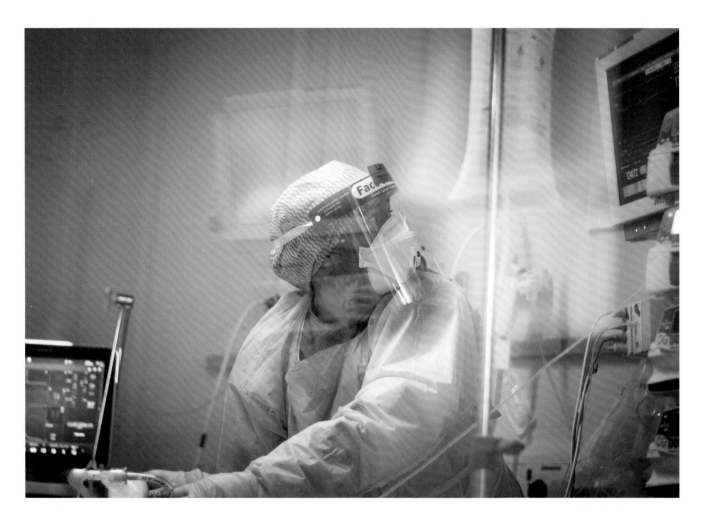

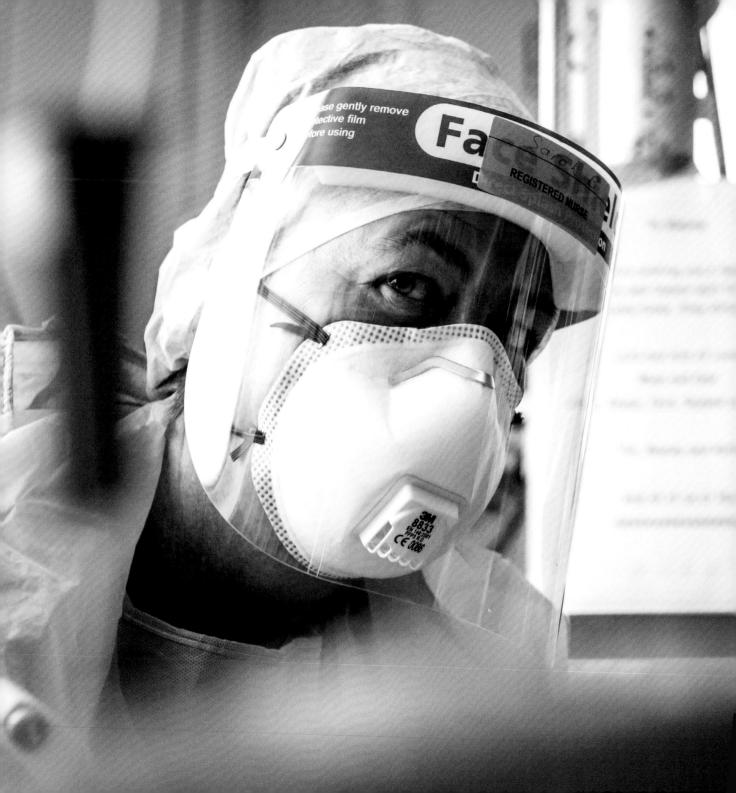

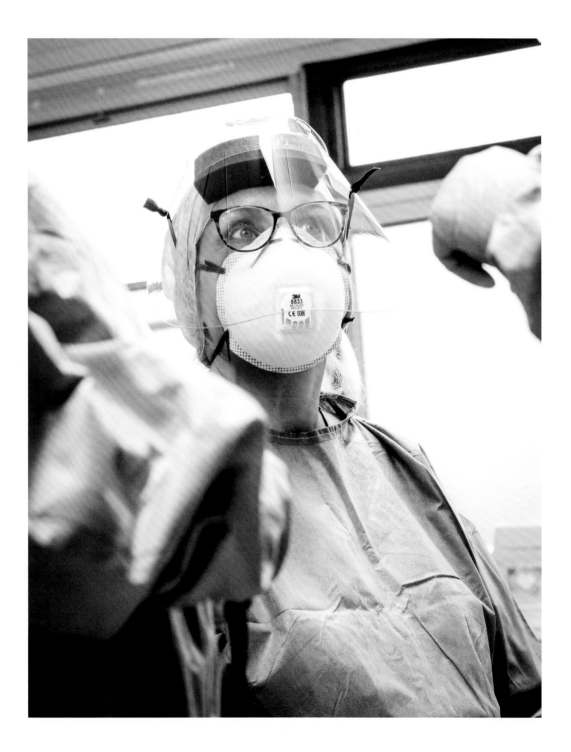

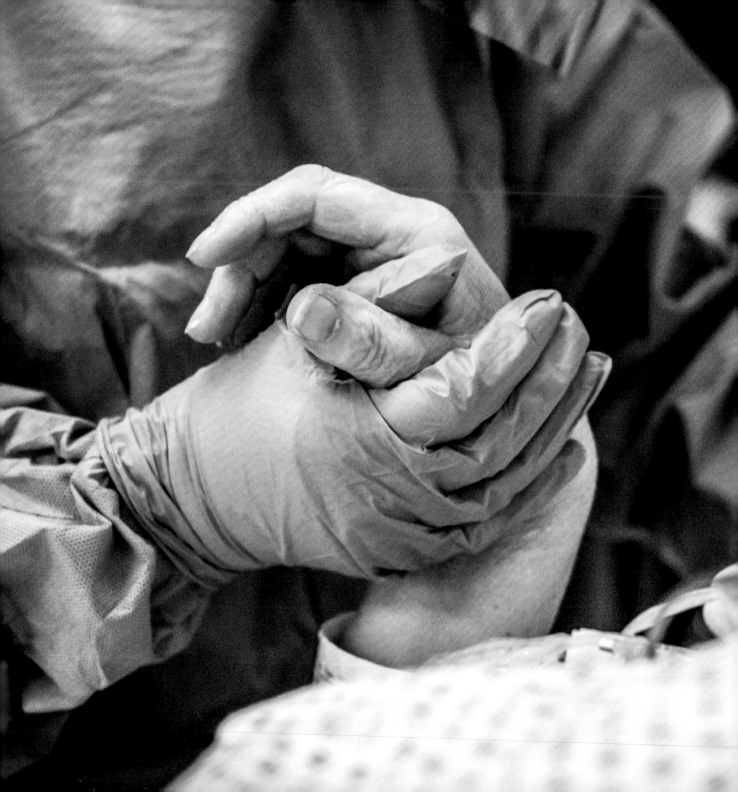

But the patient will not die alone. The nurses will always be there, holding their hands and talking to them until the end.

Sadly, as I noted before, we expected to lose approximately half of all patients that end up needing ITU during this pandemic, and explaining each loss to the loved ones of those who don't make it is tough enough when it is face-to-face and they can see their loved one and hold their hand at the end. Without relatives being allowed into the hospital, having to do this over the phone is heart-breaking and probably the cruellest twist of all.

But the patient will not die alone.

The nurses will always be there, holding their hands and talking to them until the end.

The nurses have probably had the toughest time throughout this pandemic. Or, more correctly, the healthcare professionals doing the usual jobs of the ITU nurses. For even if we can find more bed-spaces, buy more ventilators, more drug pumps, more drugs, we still can't buy more of the thing that sick ITU patients need the most – the ITU nurse. Without an ITU nurse tree growing locally, we had to adapt and overcome to fill the potential gap in numbers if the surge happened. We asked ITU staff who had left for other jobs to come back. We asked nurses who've never worked in ITU but had transferable skills to come and help us. We asked theatre assistants and healthcare assistants from the wards to come and help us. And no one refused, everyone wanted to help. Even though they probably felt like they were putting themselves on the front line, they wanted to help. We had multiple crowded training sessions for everyone to familiarise themselves with PPE, the ventilators, the pumps, the drugs, the paperwork.

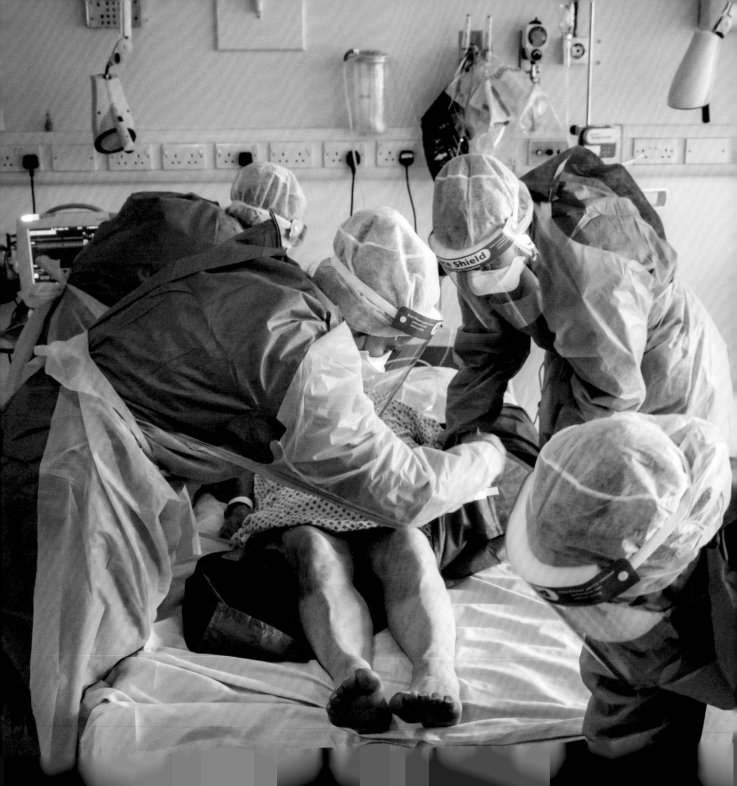

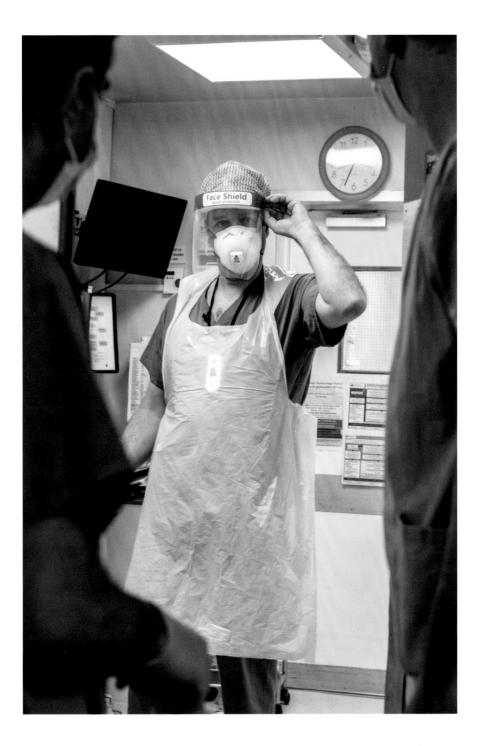

'As an anaesthetist the last few months have been the most physically, mentally and emotionally exhausting of my career. The daily interaction with colleagues and friends in hospital has been so important in allowing me to keep my focus on the clinical situation and stay sane.'

Graeme Lilley, Consultant Anaesthetist.

We practiced turning patients onto their tummy, or 'proning', as we knew from China and Italy that many may need the help this gives to oxygen levels when the ventilators are on maximum and it's still not enough. And as the patients started filling the beds, these brilliant people who, six weeks before, had never dreamed they would be doing such a harrowing job, pulled up their socks, donned their PPE and got to work; quietly, unassumingly and professionally.

And what of the fully trained ITU nurses? Well, they had all these new protégés to teach and supervise as well as look after the sickest of the sick patients. They had to step up and lead shifts when they'd only previously followed; they had to adapt and overcome when the unexpected happened, all the while overseeing the care of far more patients at once than they were used to. As well as this, they were the nurses who spent time speaking to the relatives over the phone or video call, showing them their loved one asleep on a breathing machine and holding the patient's hand if the worst happened and we couldn't save them, sometimes even video-calling the relatives to help them try to share that moment.

Sometimes these shifts broke them emotionally, sometimes the gruelling hours in PPE broke them physically, but they never lost their humour, their morale or their professionalism.

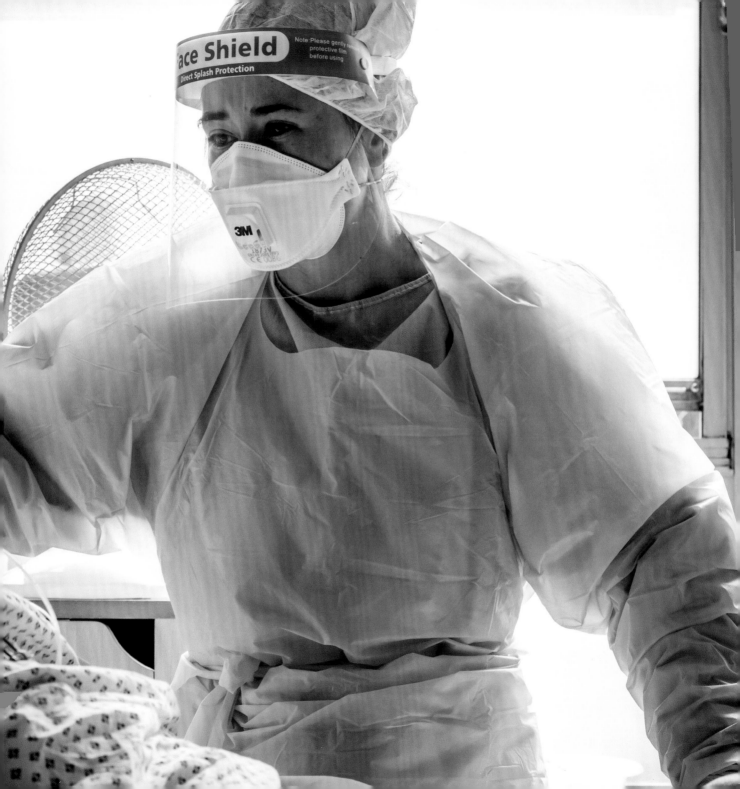

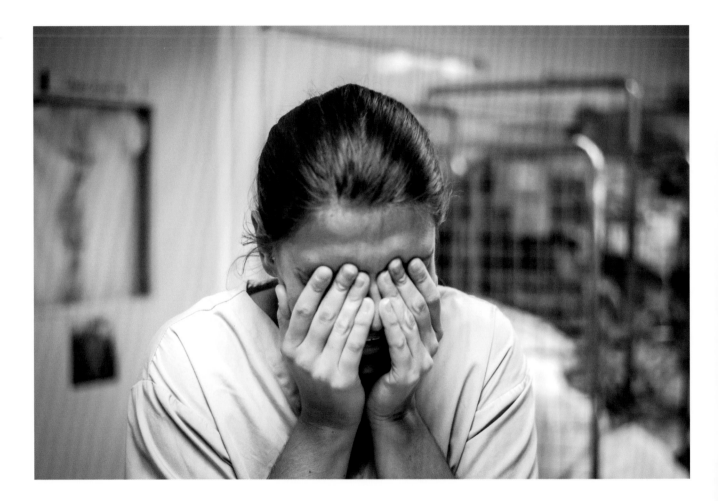

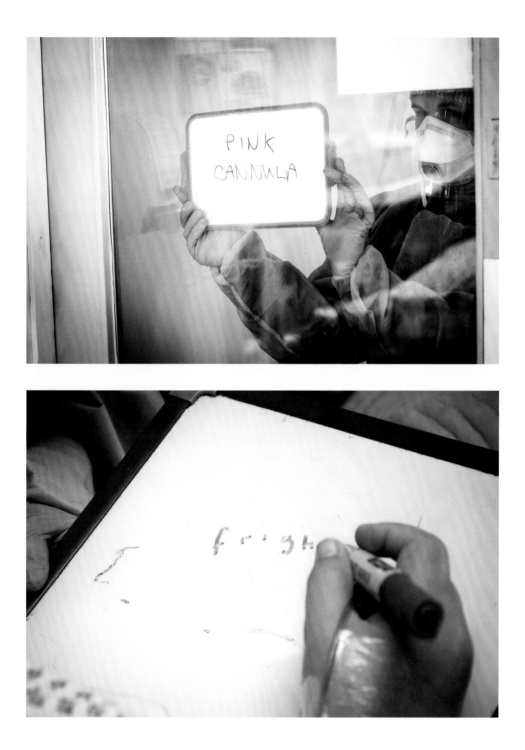

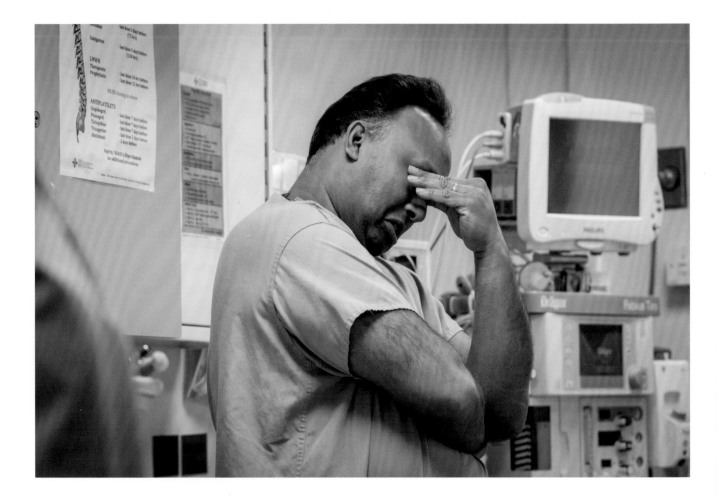

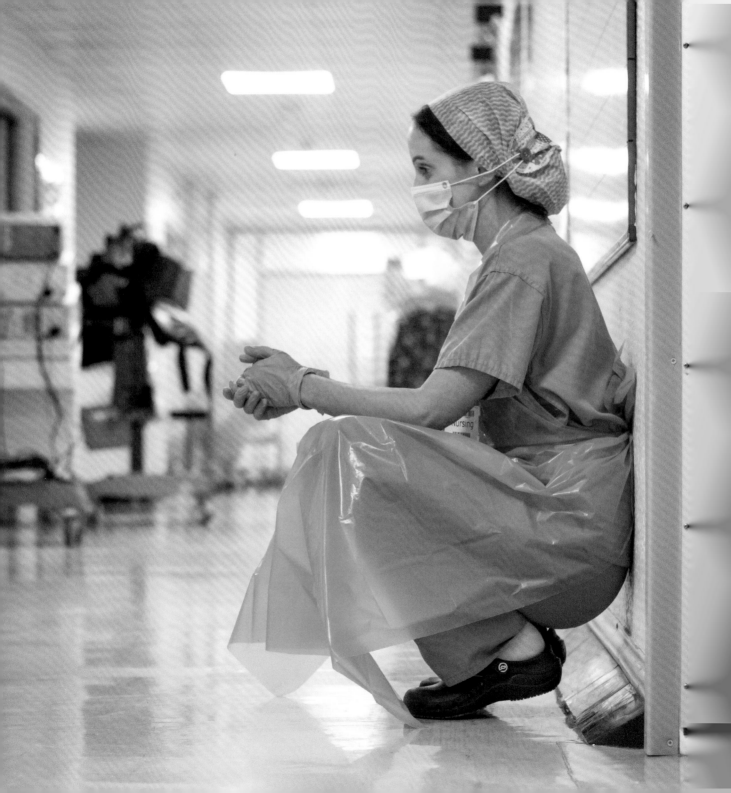

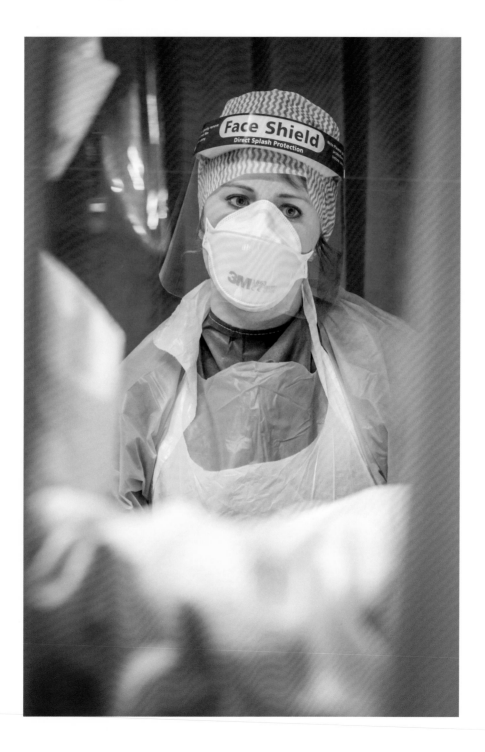

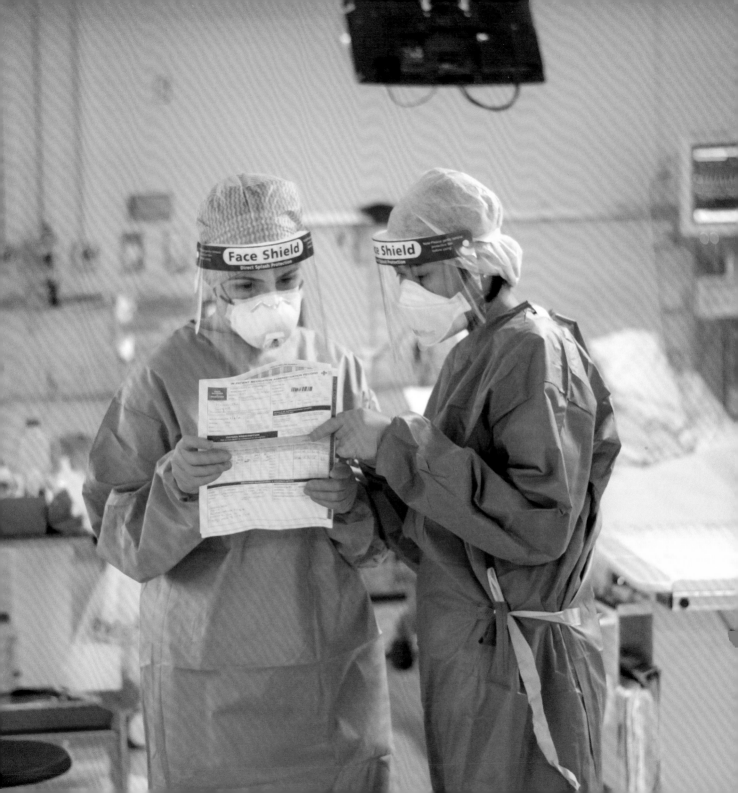

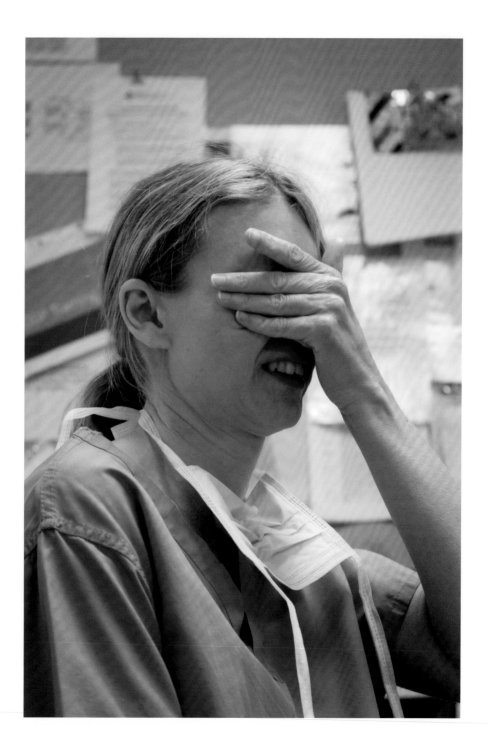

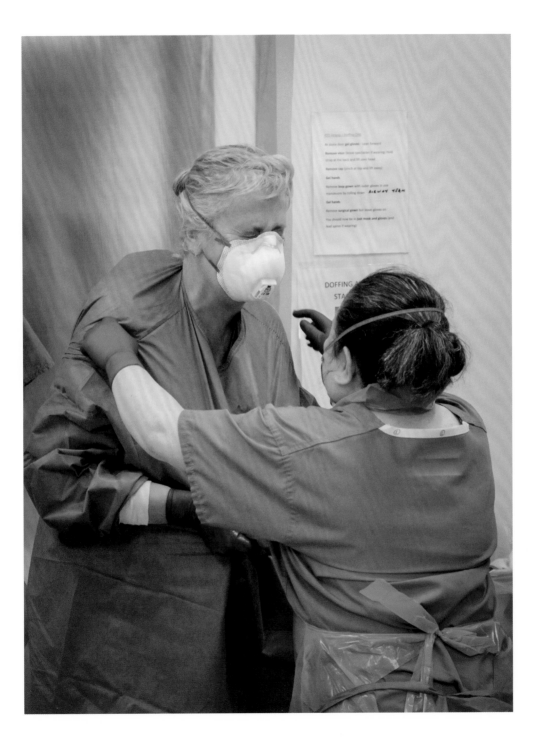

47

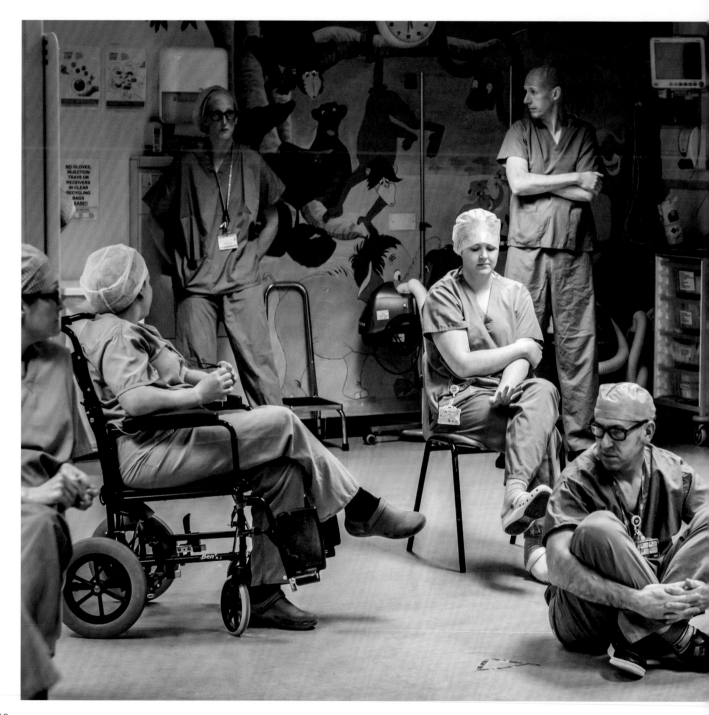

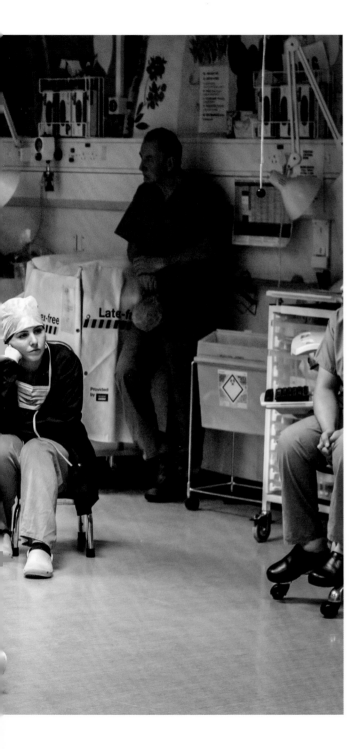

'During the pandemic I have felt apprehensive, scared, worried for my family and loved ones and generally anxious, but as always put my own feelings aside and do my job to the best ability that I possibly can. Together we will get through this.'
Lynn Emmit, Scrub Nurse.

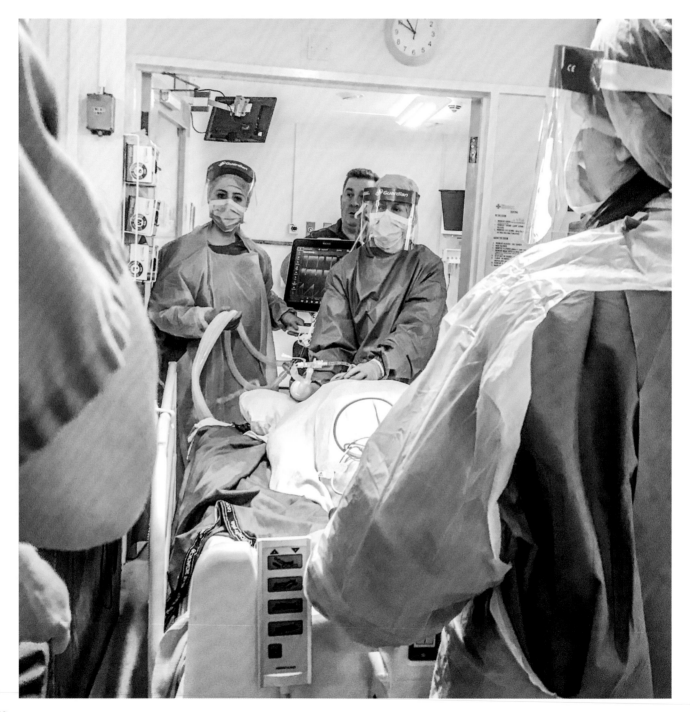

**These nurses would be the lifeline for the patients and their relatives over the coming weeks.**

Sometimes these shifts broke them emotionally, sometimes the gruelling hours in PPE broke them physically, but they never lost their humour, their morale or their professionalism. In fact, by the end of the first surge all of those staff; scrub nurses, A&E nurses, recovery nurses, ODPs, theatre assistants and, of course, ITU nurses; all who had won and lost patients on ITU together had bonded like family – like a band of brothers (or sisters!)

These nurses would be the lifeline for the patients and their relatives over the coming weeks. Once the doctors had anaesthetised the patient and placed them on a ventilator, inserting lines into their arteries and veins and prescribing medication, it would be the nurses who would deliver those medications, take blood tests, roll the patient, clean them, brush their teeth, hold their hand, speak to their distraught family and alert the doctors to any serious changes in the patient's condition. The doctors would review their patients regularly, making changes to their ventilators, add to the list of drugs to be given, review blood tests, decide who needs to go onto a kidney machine, add in blood pressure support drugs and other machines to help the patient if their organs began to fail. It was also the doctors that would speak to the families if the tide started to turn against the patient; if we started to lose the battle despite throwing everything at them, if the likelihood of them dying steeply exceeded the glimmer of a chance of them getting better. A tough enough chat to have in normal times, but far better face-to-face when you can read people's faces and see how they are processing the information they are being given. A heartbreakingly tough discussion to have over the phone with someone you've never met.

And what of the patient? Mostly they would be unaware of what is happening to them; the cocktails of drugs rendering them quite heavily sedated so they can tolerate the ventilator pushing oxygen into their lungs, especially if they require 'proning'. But they are not peacefully sleeping, far from it. Their body is running a marathon every single moment of every single day, trying to fight off the infection. The effect of this over time is marked; you can see them physically weaken as the days go by. You have to remind yourself that three weeks ago they were a perfectly fit and well individual who went to work, picked the kids up from school and cooked dinner, just like you. They were not the frail, sick, close to death person you see in front of you right now.

But if what we are doing helps, if their infection starts to subside and they begin to improve, then we lighten the sedation, let them wake up and see if they can cope without the breathing machine; see if they are well enough to take the breathing tube out. Sometimes they are so weak they can't cope without the machine, so we perform an operation called a tracheostomy where we insert the breathing tube into the front of their throat so that it no longer passes through the vocal cords from their mouth. This is more comfortable for the patient and allows us to lighten the sedation, which means we can try the patient off the ventilator for short periods of time and simply plug them back in again if they need it.

**Their body is running a marathon every single moment of every single day, trying to fight off the infection.**

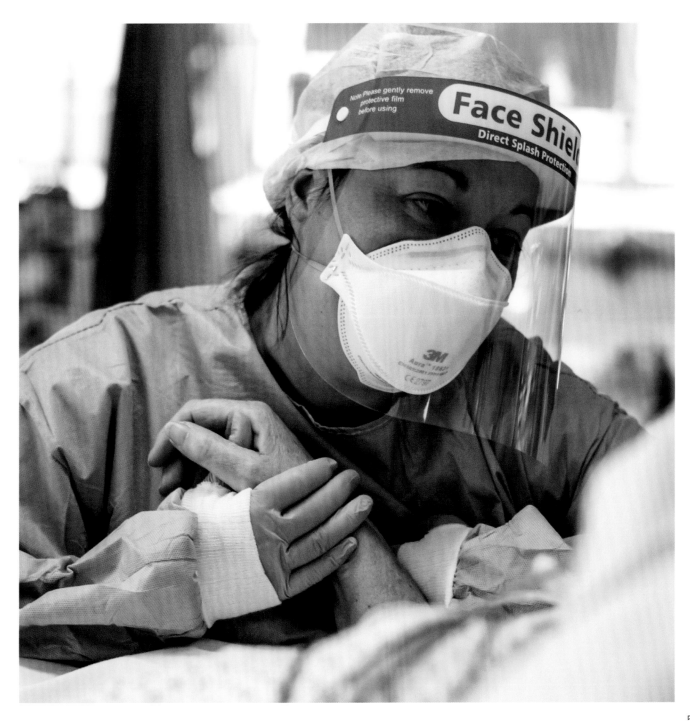

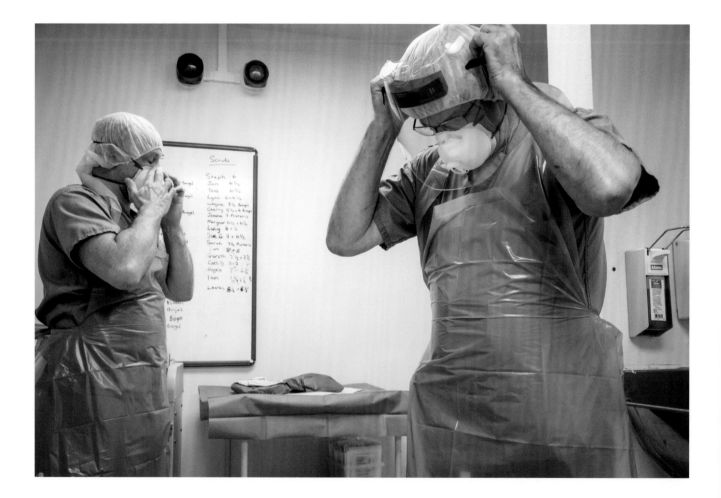

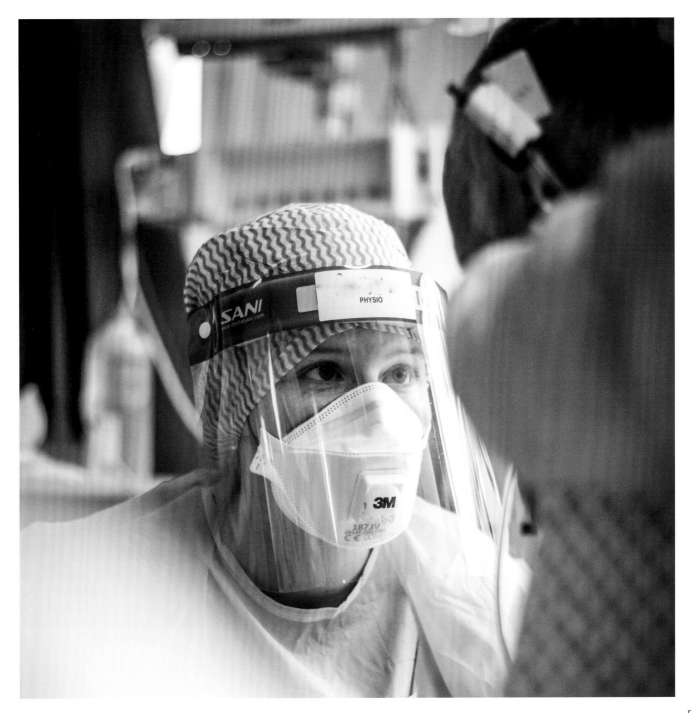

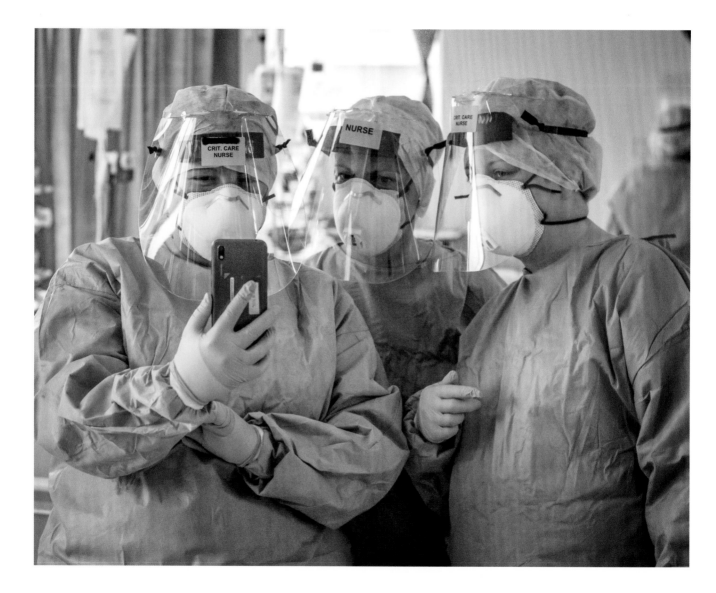

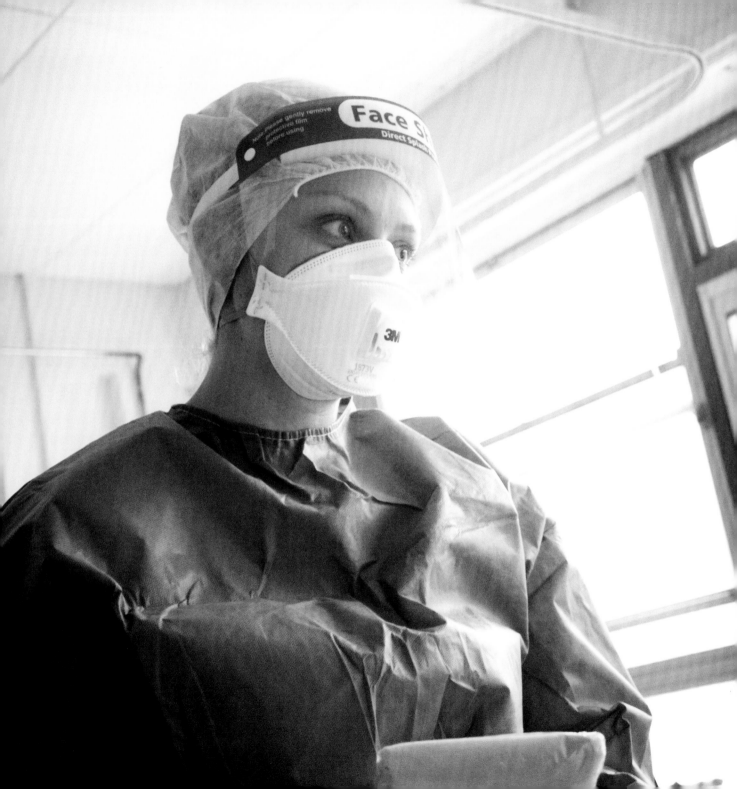

'I felt out of my comfort zone. I wanted to comfort patients and my colleagues.'

Nicole Fury, Theatre Assistant.

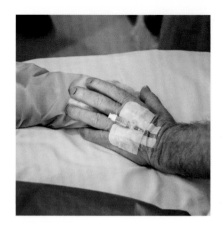

Once we get to the 'getting better' stage then we actually get to see a little of the real patient shine through. This is not the fit and strong person we put to sleep three weeks ago; they don't know where the time has gone, they have huge gaps in their memory, they've had weeks of odd dreams, often nightmares, and they may still be quite delirious from a combination of the drugs and the illness. They may remain in this state for some time, but in normal times what usually eases many through is visits from family, from friendly faces. Now, however, they will have to make do with kind strangers in masks and hopefully a WhatsApp video call from a loved one if we are able to get the technology to work. They are mentally in pieces and physically as weak as a kitten from their twenty-one consecutive marathons and they have no idea what has happened to them or, because their arms and legs haven't moved normally for weeks, why everything hurts. The last thing they remember may be visiting the GP or going shopping, they may not even remember being ill at all. To help them piece together the lost time we write diaries for them every day but the recovery will take time, both physically and mentally.

They will have to make do with kind strangers in masks and hopefully a WhatsApp video call from a loved one if we are able to get the technology to work.

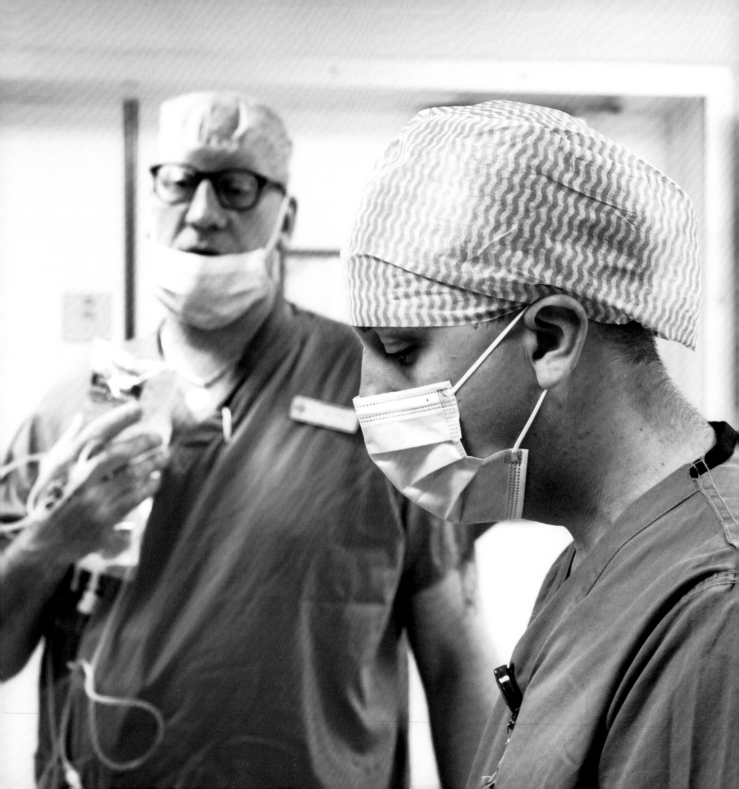

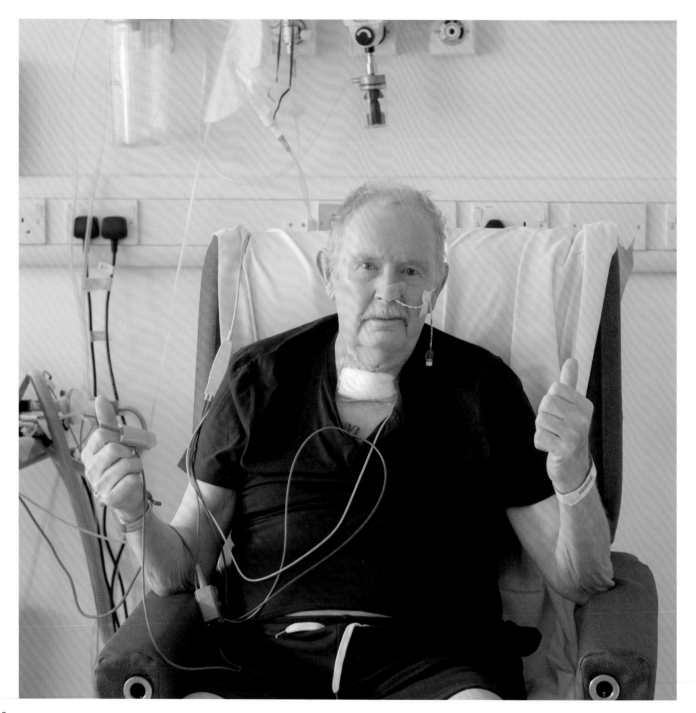

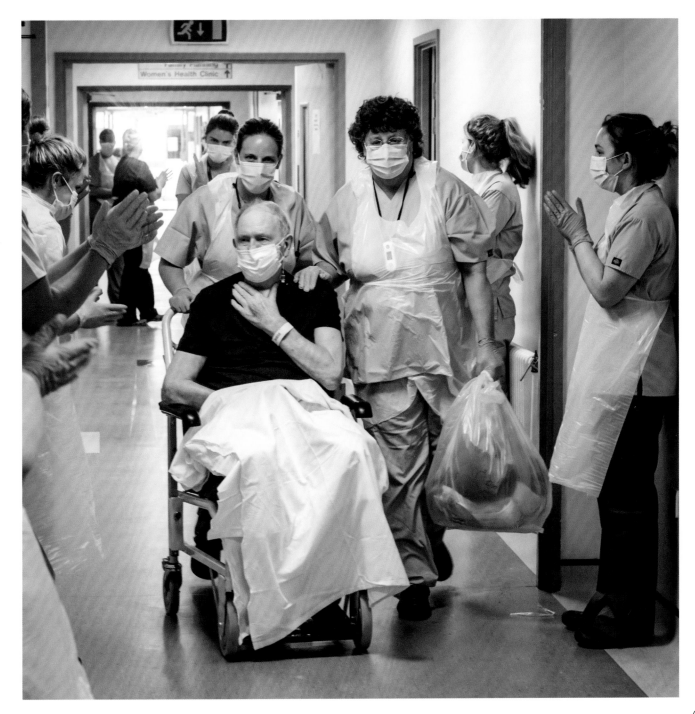

61

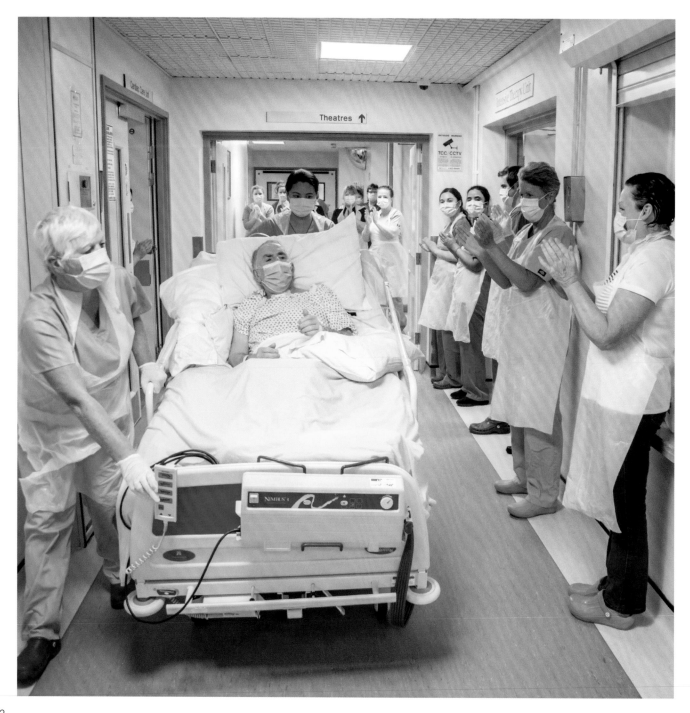

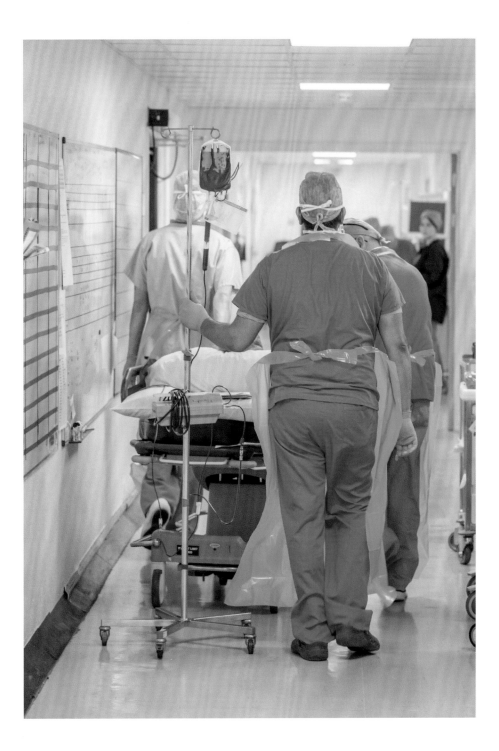

'I feel proud. Proud of my team. How they've been allocated to areas without question or strife. I'm proud of my family who have moved out and not seen their wife or mother for six weeks, allowing me to give all my time to the NHS. I'm proud of the public for helping us in any way they can. I'm proud of the 'village' hospital that has faced coronavirus head on.'
Laura Kingscott, Theatre Sister.

As they leave our unit and head to the ward, with staff lining the corridors to clap them on their way proud that their hard work has helped them to survive, the hard work has really just begun for them. They have survived intensive care but their fight continues; they still need to recover the strength to walk, the coordination to eat, to learn what of their memories are true or imaginary, to learn what has happened in the world and to their families during the time they were unconscious. The army of physios, dieticians, pharmacists, speech and language therapists and psychologists who've worked so hard with the patients whilst they were critically ill in ITU will now follow these patients to the wards and be a continual and important part of their hospital journey, some of them even seeing them as out-patients when they have recovered enough to get home to their families.

And what about those who didn't make it? The unlucky 50%. Were they older and sicker to start with so it was no surprise really? In normal times this would probably be the case; we would be able to anticipate who probably wouldn't pull through, whose illness was just too much for them as they had significant medical problems prior to coming through our doors.

As they leave our unit and head to the ward, with staff lining the corridors to clap them on their way proud that their hard work has helped them to survive, the hard work has really just begun for them.

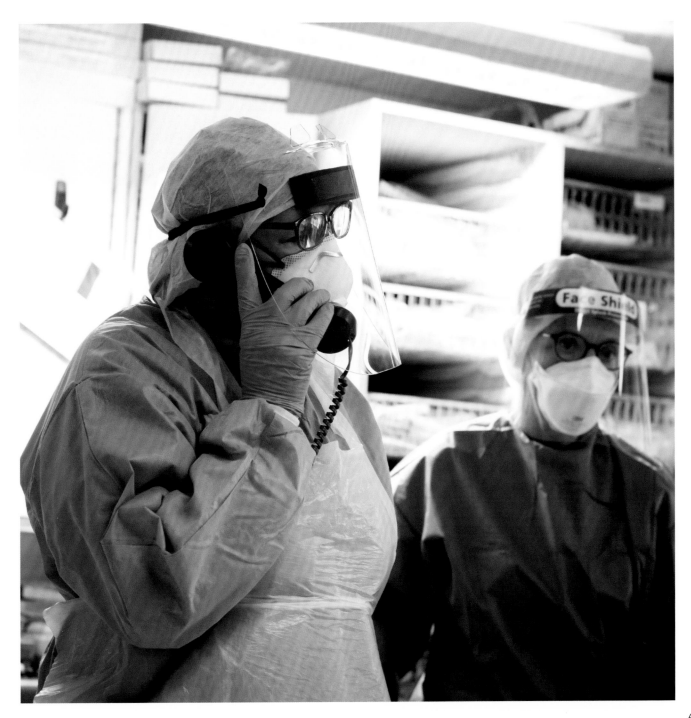

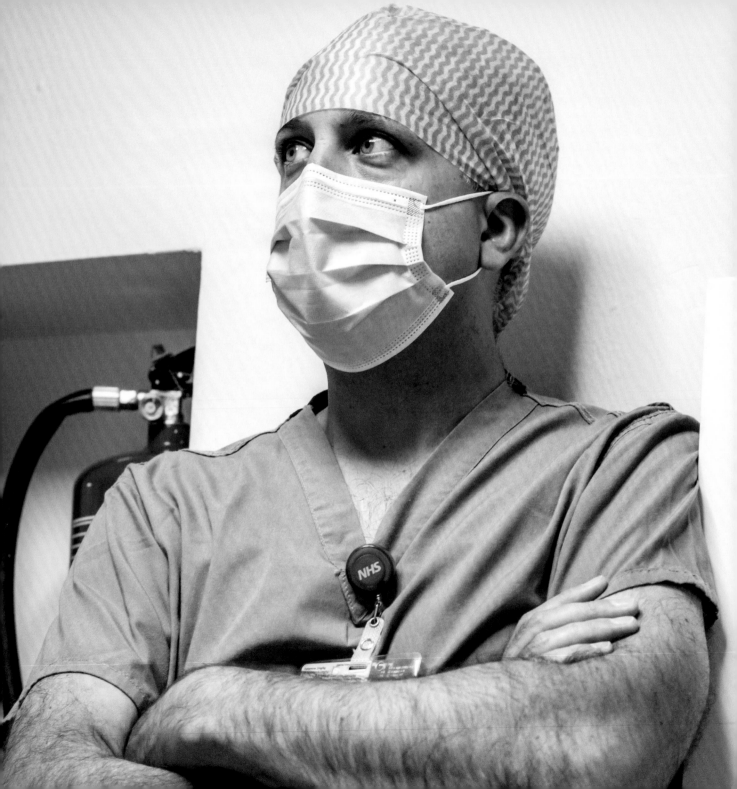

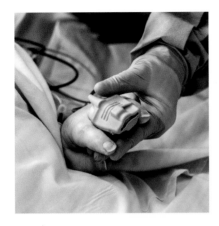

'Petrified for my health and my family. Worried for my team and colleagues. Everyone has been affected mentally for different reasons. Everyone has battled their own personal circumstances and demons to cope. I worry this will come again.'

Julie Morgan, Recovery Sister.

Many of them were young, younger than those of us caring for them, and despite everything we did and despite how hard their bodies fought, they died.

But in these weird times of COVID a lot of our patients were pretty young, fit and independent prior to needing us; on paper they should almost all survive, but COVID doesn't play by the usual rules. Despite our best and hardest efforts some of our patients did not survive. They weren't the oldest or those with the most medical problems. They were those who despite everything we did, every machine we put on them, every drug we pumped into them, just got sicker and sicker until we had no more machines left and the drugs and ventilator couldn't be turned up any higher. Many of them were young, younger than those of us caring for them, and despite everything we did and despite how hard their bodies fought, they died. We would ring their relatives, warn them that we weren't winning and death was imminent, apologise that they couldn't come in and visit, promise that we would be with them until the end and that they wouldn't die alone. This is probably the hardest part of this whole situation; not being able to care for the relatives the way we usually do and not being able to have them there at the end as would usually happen.

And the rest of the hospital? They were still busy; not all patients with COVID needed us or would benefit from us so the medical

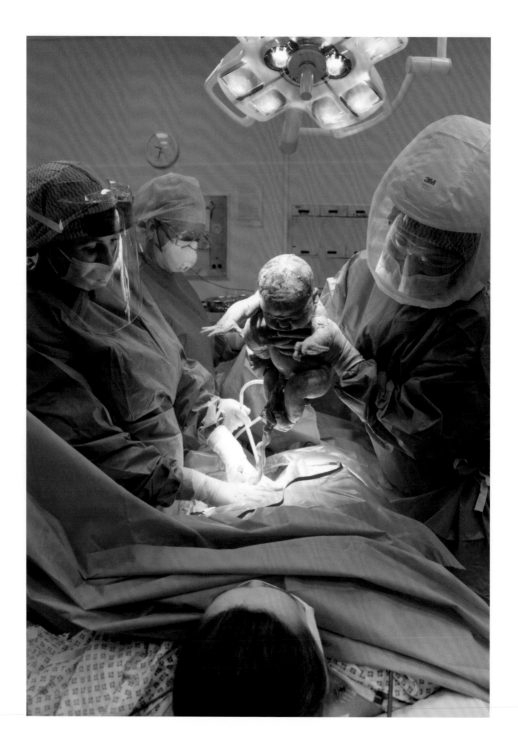

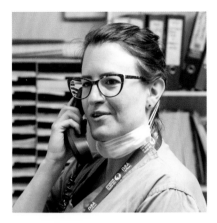

'We are nervous but we don't show it. Working in obstetrics is a reminder that life goes on. Behind our PPE there are reassuring words, a hand to hold and always a smile behind our mask. Covid will not stop us. We will always be with our patient and the birth of a new life is truly beautiful.'

Amy Hayman, Midwife.

A splash in the pool of happiness and a new life to celebrate was a welcome break for all of us and we had to make sure that it was still a special moment for the new parents.

wards were very busy. And there was still a comforting degree of normal life going on just down the corridor from us. The hospital's labour ward and maternity theatre are literally a stone's throw from the doors of our ITU. The corridor between us had been segregated, essentially split into two halves which put the death and anxiety of ITU at one end and the joy of new birth, new life at the other. Our anaesthetic and scrub staff were in the odd position of caring for both sets of patients during various times of the week; intubating and caring for a patient with COVID on one shift, anaesthetising a pregnant lady for a caesarean section the next. We couldn't bring our sadness about what was happening down the corridor to the happy occasion of a birth, and nor did we want to; a splash in the pool of happiness and a new life to celebrate was a welcome break for all of us and we had to make sure that it was still a special moment for the new parents. It wasn't their choice to have their bundle of joy arrive during this awful time and they were probably already anxious about even having to set foot in the hospital. We had to work harder than ever to reassure them and make sure that this amazing occasion, an arrival of new life, wasn't overshadowed by COVID as everything else had been.

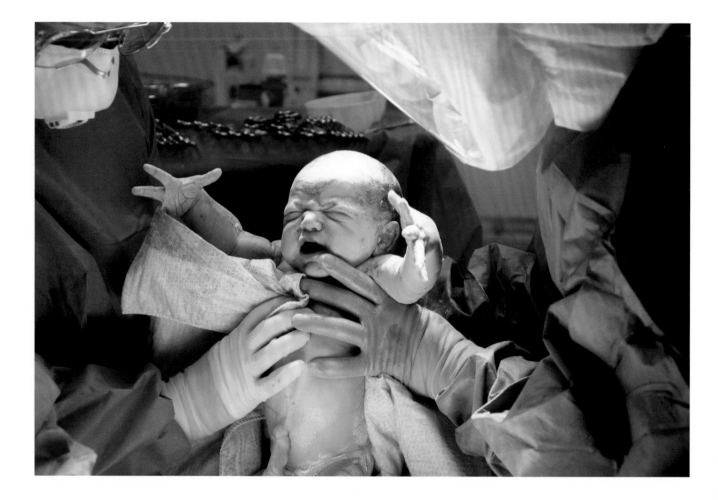

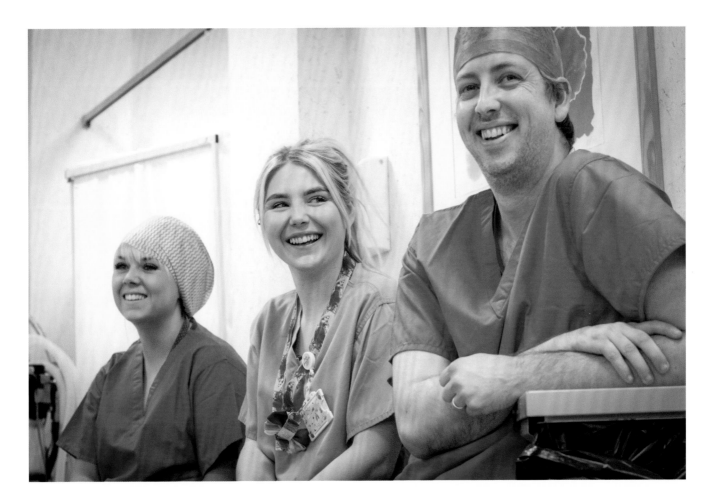

'Blood, Sweat and Tears. It's been a scary situation to be in. I learned new skills, worked alongside a lovely group of people and enjoyed the challenge. We had hard times but happy times also. I am proud to have played my part in the team.'

**Toyah Barton, Senior Operating Department Practitioner.**

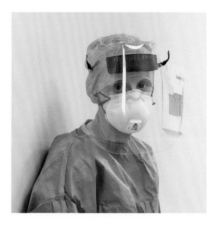

Which brings me on to the future. I sit writing this just days before lockdown is seemingly going to begin to be lifted and lots of people are asking me what I think will happen next. Now I know that people want parties and victory parades and life to go back to normal, and so do I, but sadly this is nowhere near what can or will happen in the coming months.

The virus is still very much at large, it has not gone away. We are still receiving patients into our hospitals every day who've been affected, it's just that lockdown has successfully reduced the tidal wave to more of a steady drip. Life will not go back to being the same, it cannot, or we will find ourselves in the same position we were a few weeks ago; expanding into our third ITU, preparing to quintuple our intensive care numbers and the hospital buying up extra mortuary space. Instead people will need to embrace this new, stricter way of life for a while, where social distancing, compulsive hand washing and not going out and meeting whoever we want, whenever we want is the new normal. It's the only way to keep numbers of sick people at a level that the health service infrastructure, and us as healthcare professionals, can physically and emotionally cope with.

We were never put into the situation during the first wave where we had someone who needed a ventilator but we didn't have one available, and I hope that we never are.

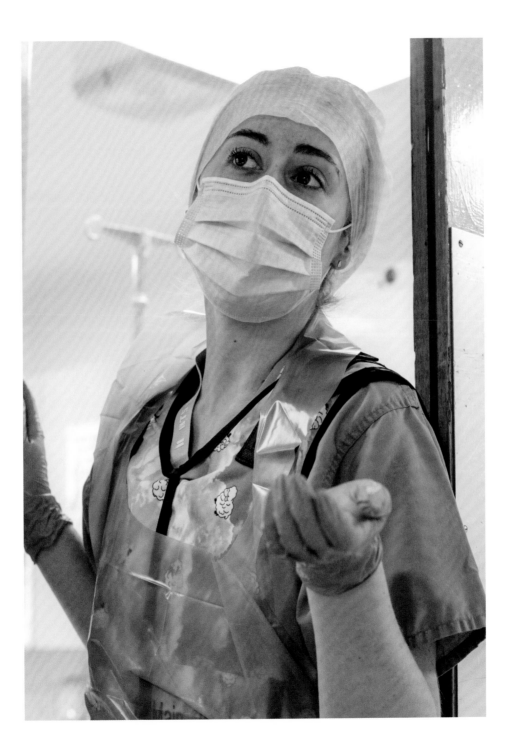

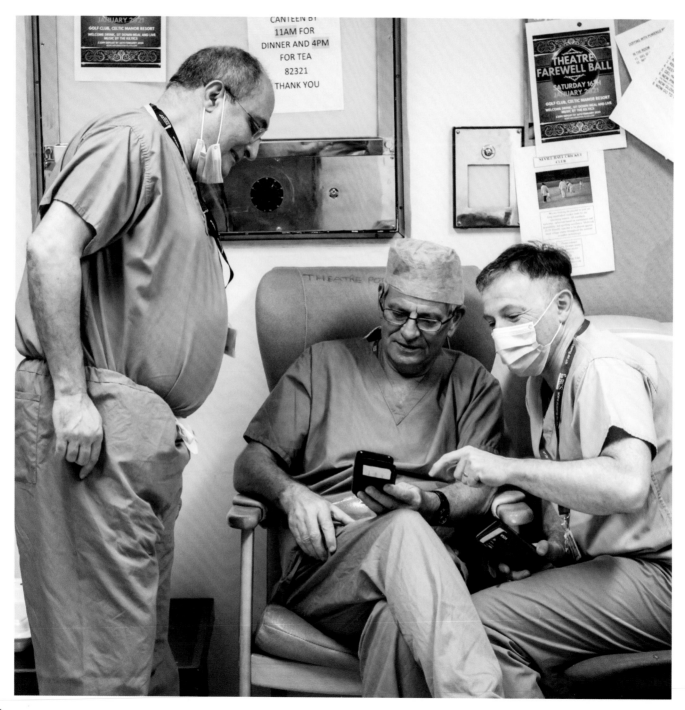

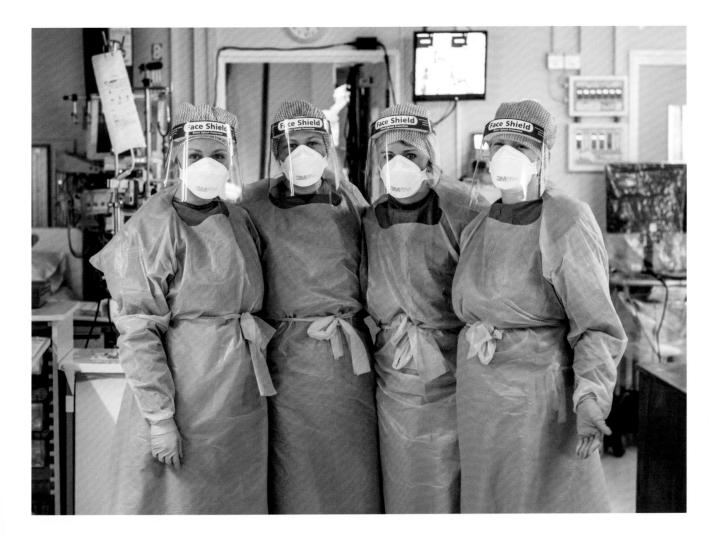

'Working as a physiotherapist during COVID-19 has been a challenge, but also a privilege. As a physiotherapy team we have bonded over the highs and lows. We are thankful for being able to share the important first steps of a patient's recovery with them. Those touching moments are the reason we chose our profession and why we are proud of our NHS.'

Laura Kimberley, Band 6 Cardio-Respiratory Physiotherapist.

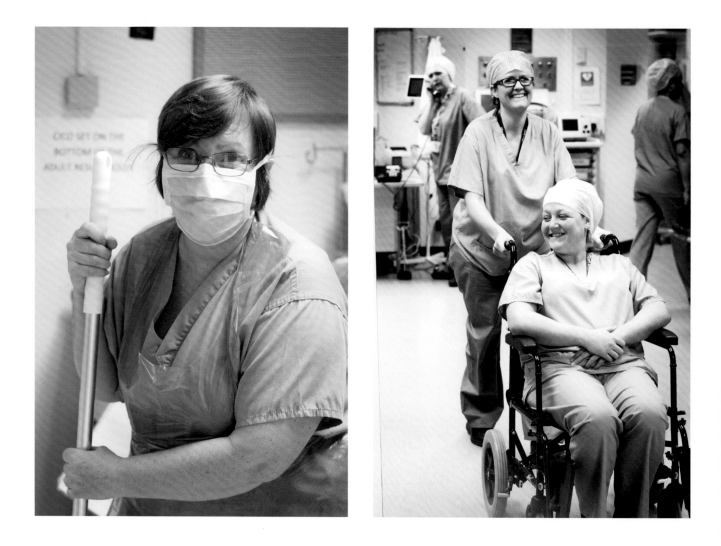

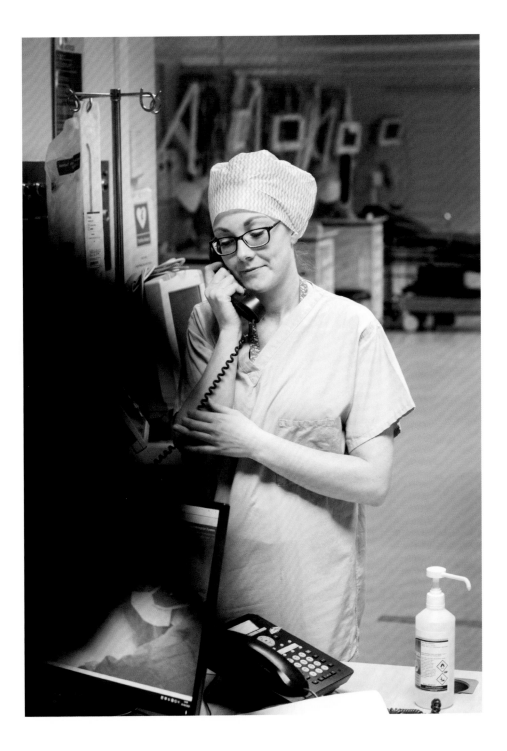

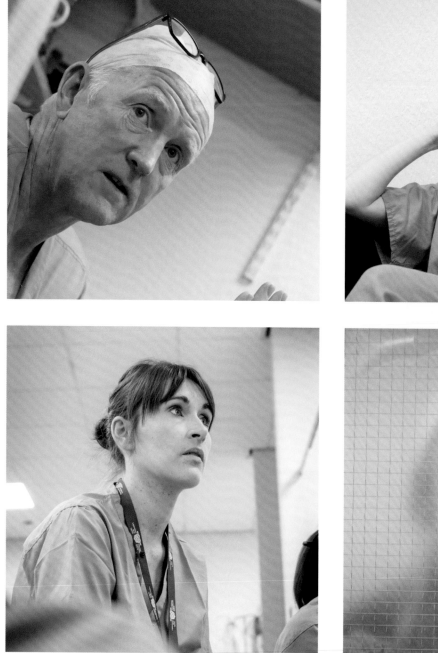
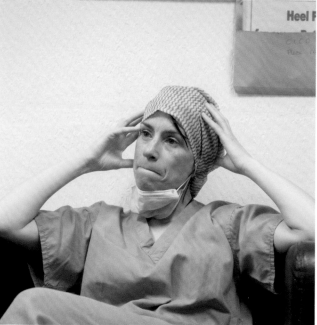
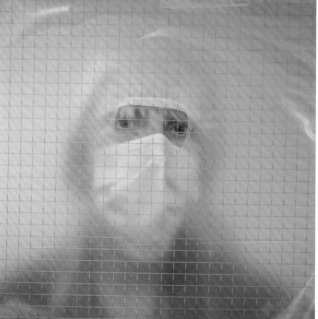

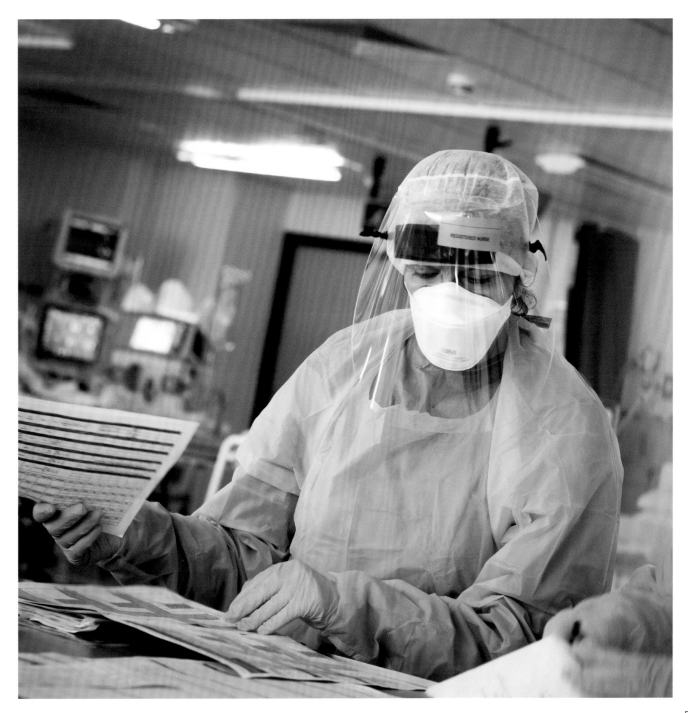

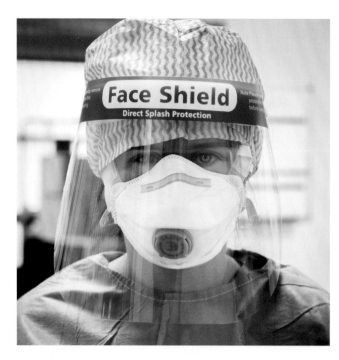
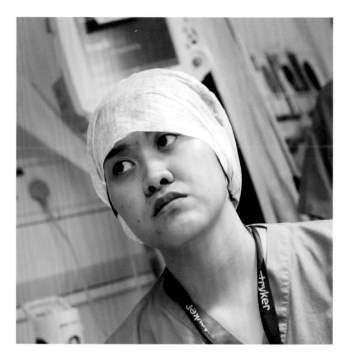
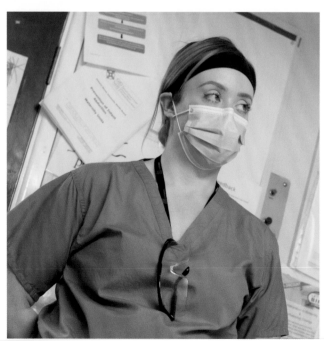
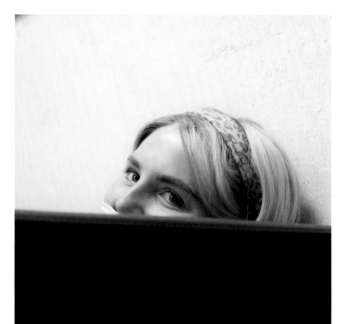

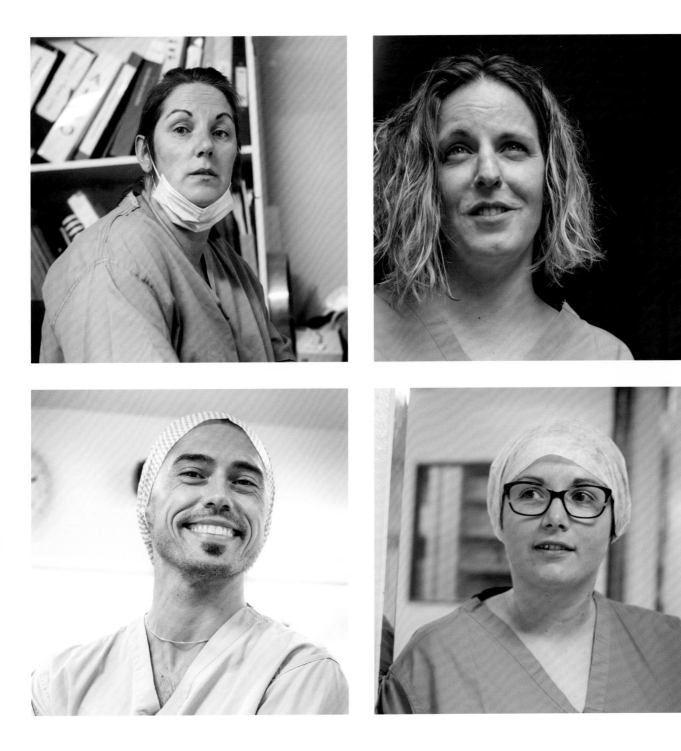

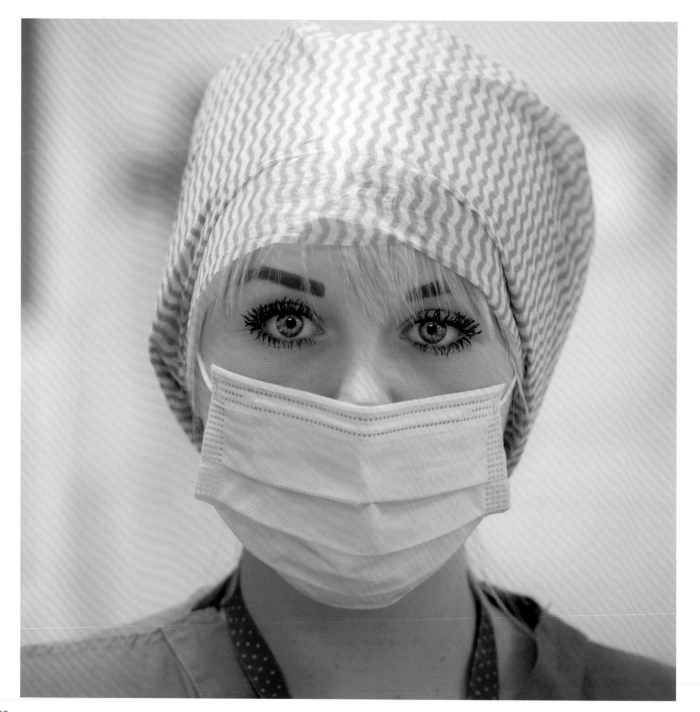

'During 2020 everyone stepped forward to turn the wheel of the NHS. Without their strength, support, loyalty and determination, many more would have fallen.'

Steve Bates, Theatre Assistant.

**But a second wave, I feel, is sadly inevitable. How will the hospital cope a second time? Well, we know what to expect this time, and people certainly know a lot more about the disease.**

We were never put into the situation during the first wave where we had someone who needed a ventilator but we didn't have one available, and I hope that we never are.

But a second wave, I feel, is sadly inevitable.

How will the hospital cope a second time? Well, we know what to expect this time, and people certainly know a lot more about the disease. Many of the healthcare professionals drafted into new parts of the hospital, especially into ITU, have much more of a clue about what they are doing; they have become donning and doffing ninjas and showering five times per shift due to aerosol exposure is literally like water off a duck's back to them. But even if they are trained and experienced, are they mentally and physically prepared to go through this again? Everyone is tired and many of us have what has been coined 'COVID fatigue.' Aside from the hours we've actually spent in work we've also been living, breathing, eating and sleeping COVID for the last two months outside of work; devouring any new article or paper that comes out in case it might help our patients, waking up in a cold sweat thinking about the ones we couldn't save, losing track of what day it is or when we last had a day off, with only the Thursday night 'claps' orientating us slightly as to what day of the week it is.

'Proud is an understatement. Watching the Operating Department Practitioners carrying out COVID intubations and other emergencies on a daily basis, nothing phased them. A fantastic team that I am proud to be part of.'

Archie Cameron, Senior Operating Department Practitioner.

The new and old ITU staff rose to the challenge during the first wave and I'm sure they will do the same again for subsequent waves, but they are war-weary and have been emotionally battered. Although we've been taking care of each other and are acutely aware of 'wellbeing', if the pace of work ramps up again we'll not only have to spend much more time and energy on our patients but also on personally surviving, which means having less time to spend on looking out for each other as we just won't have the bandwidth to do it all.

I'm sad to think of being us all being put into this position again, and I'm also sad at the thought of tens, maybe hundreds more patients being put through the 'ITU machine' again. ITU is a magical place but it comes with a cost, even for the patient who beats the odds and survives, and this is especially true for patients who are admitted due to COVID as they really are the sickest of the sick. COVID is one of the most horrific diseases I have ever had the displeasure to do battle with. It follows no rules, it takes no prisoners and I have never felt so helpless as a clinician as I have in the last two months. We have no proven treatment, no vaccine and although we are giving the best evidence-based care that we can, we are still working almost blind with no 'magic bullet' that can destroy the virus at source and prevent its rampage through the body.

The new and old ITU staff rose to the challenge during the first wave and I'm sure they will do the same again for subsequent waves, but they are war-weary and have been emotionally battered.

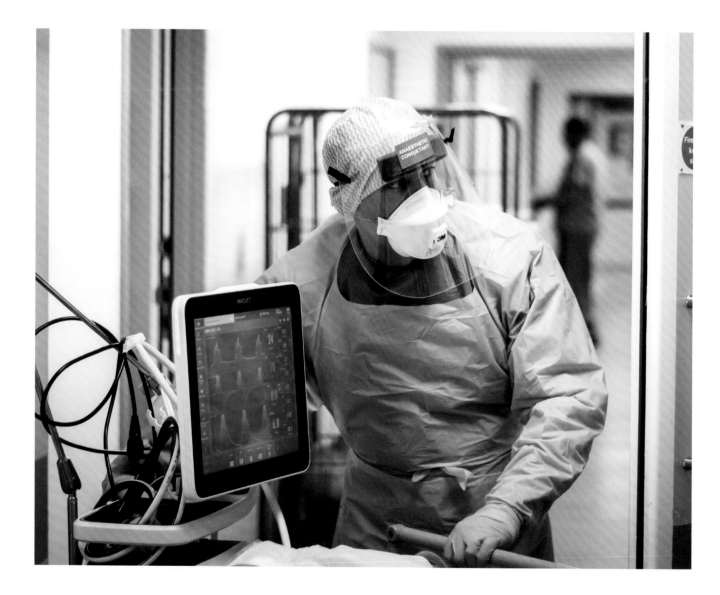

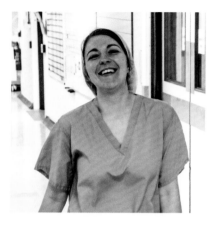

'During this time of pandemic, the feeling of stress felt by many is unparalleled.'
Kayleigh Vaughan, Theatre Assistant.

COVID has forced the NHS into front and centre of everyone's hearts and minds once again and reminded people what is actually important to them.

I hope that I'm wrong and that all of this suffering just goes away and life gets back to normal, but I also hope that the outpouring of love that people have shown to the NHS doesn't go away. We have always been here for you, 24 hours a day, 365 days of the year, for the good times and the bad, and I hope we always will. At a time when increasing privatisation of parts of the NHS, the removal of nursing bursaries, disputes over junior doctor contracts, and pension tax woes were driving many talented healthcare professionals away from their profession and the bottom seemed to be beginning to fall out of the organisation, COVID has forced the NHS into front and centre of everyone's hearts and minds once again and reminded people what is actually important to them. It's people that are important. Not money, not possessions, not how many likes on Instagram you can get.

Just people.

I hope that we don't forget the lessons that COVID has taught us, even if she has been the cruellest of teachers.

'I was very apprehensive about moving to ITU and with good reason after finishing my first shift. It was like walking into the unknown. Patients on ventilators I'd never used before, drugs I'd never given and patients that could become seriously unwell, very quickly at any moment. It was physically challenging, so hot wearing full PPE for hours on end with masks cutting into your face but we knew we had to do it for the well-being of our patients, colleagues and family back home. However for me, the emotional side was the most challenging. I'm so proud to be a part of it with all my NHS family.'
**Steven Jones, Operating Department Practitioner.**

'PPE seemed to change daily along with services. However throughout our teamwork shone through. Theatres, ITU, Anaesthetics, Maternity all showed resilience, humour and compassion but most of all support for one another.'
**Cath Graves, Senior Midwife Manager.**

'A feeling of responsibility I have never faced before. Holding a patient's hand and willing them to live for the sake of their poor family who can't be with them will live with me forever.'
**Louise, ITU Nurse.**

'Fear of the invisible enemy. However, our faith and prayers and our dedication to care for our patients kept us strong.'
**Recovery, Theatres.**

'Nothing could prepare me for COVID-19. Walking into ITU was like walking into a horror movie, only this was very real. There were wires, pumps, flashing lights and alarms going off everywhere, but everyone kept their cool. It made me feel safe in the knowledge that the ITU staff had my back and we were in this together.'
**Andrew Edwards, Theatre Assistant.**

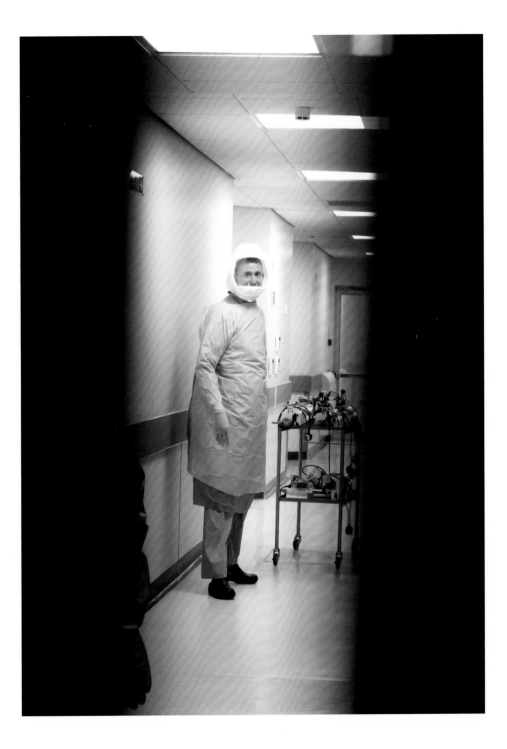

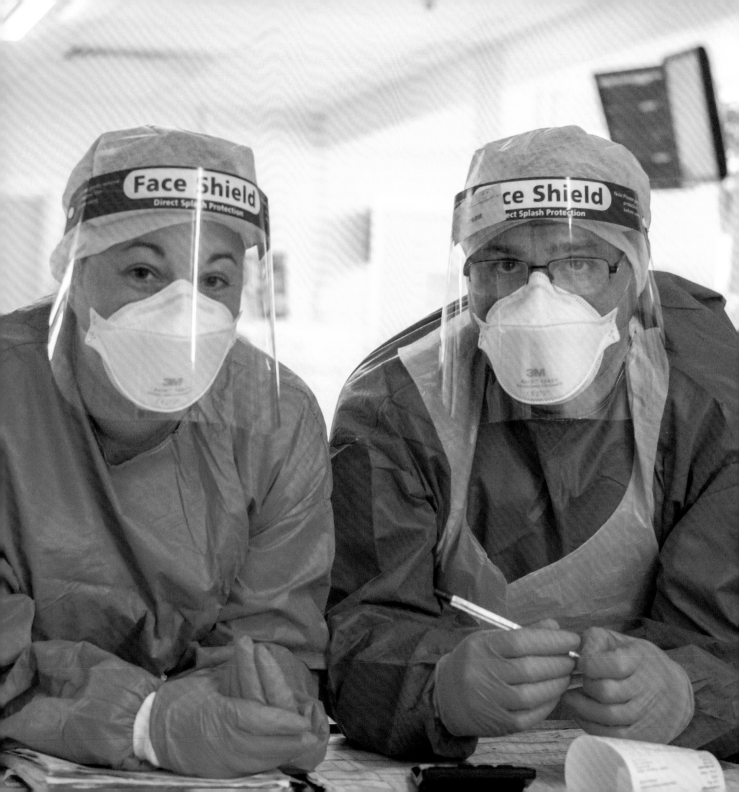

'I definitely expected my first year of nursing to be challenging. But if you had told me I'd be on the frontline, battling a global pandemic six months after qualifying I wouldn't have believed it. Through determined teamwork, a fighting spirit, and the odd laugh now and again, we made it work. If there's one thing I've learnt, even in just six short months, it's that the NHS are a family. And in times of adversity, I can always rely on my colleagues to have my back. The way everyone has united together has been nothing short of amazing. Despite the hardships, the stress and the crying, not once did I reconsider whether I chose the right career. Because being able to care for those critically ill patients, and being closely involved in their slow recovery was affirmation enough that I'm exactly where I'm supposed to be.'
**Lauren Jones, Scrub Nurse.**

'The virus has brought so much heartache and sadness to so many people and it's hard to watch so many sick patients go through ITU and not make it. But buried in all of that is a little glimmer of wonderfulness. People helping each other, breaking down barriers and acting as one big united team.'
**Louise Webster, Consultant Anaesthetist.**

'It is so motivating to see theatre and intensive care staff working together so well with very little suggestion of being overstressed or over worked. Although we are stretched we are managing, the odds are well up against us but it doesn't show.'
**Peter Colett, Core Trainee (Anaesthetics).**

'I felt anxious for my family, loved ones and my work colleagues.'
**Amy Curtis, Clerical ITU.**

'In my role, it's a real privilege to be there for patients in the moments they need us the most. We utilise our years of training and our specialised skills to provide the support they need and do everything in our power to keep them safe and well. However during this unique time, I have felt a compassion and empathy completely incomparable to anything else I've felt before. I try to channel these overwhelming emotions into being as kind and comforting as possible. I make sure patients have a hand a hold. I listen to what they have to say. I hope they know I am smiling behind my mask. I hope my eyes show it. In the darkest of moments, light has been found in the encouragement and support of all my work colleagues. They have been shoulders to cry on and a reason to smile. We hold each other up – through the highs and the lows – and it is a true honour to work alongside such incredible people.'
**Jessica Scurr, Operating Department Practitioner**

'How I felt during the coronavirus would change day by day, just like the guidelines on PPE. At the beginning I felt anxious at the unknown, as if we were going into battle. However as the days went on I predominantly had a sense of admiration for my other team members who are truly inspiring.'
**Kate Strandling, Recovery Nurse.**

'It's difficult to explain the anxiety of being redeployed to an area you feel is so out of your remit, but critical care supported me so well and despite my many sad moments, especially when patients died, seeing them improve, you have to take that as a win. Coronavirus has pushed me further than I thought I could go but I hope I never have to experience it again.'
**Samantha Thomas, DSU Nurse.**

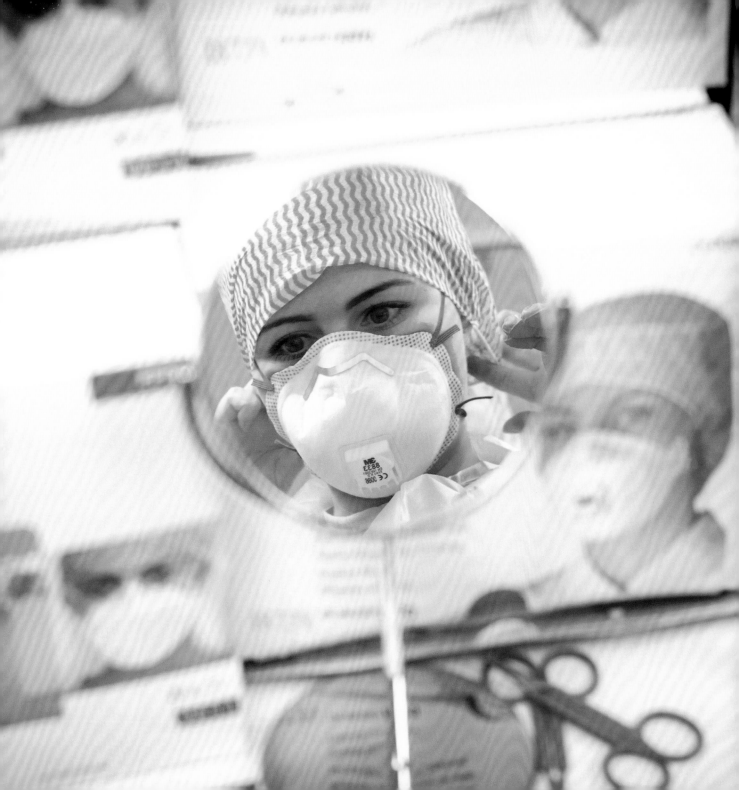

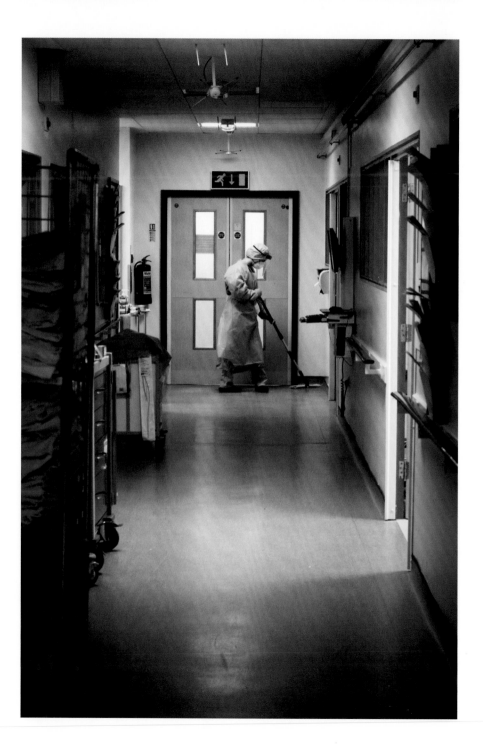

'In work I felt scared for my patients and my family and a great sense of pride for my colleagues. Outside of work living away from home protecting my family feeling generally emotionally and physically exhausted after working 12 hour shifts in full PPE.'
**Steffan Thould, Outreach/Resuscitation Nurse Practitioner.**

'I have always been proud to work in the NHS but this crisis has made me realise what it really means to be a part of that team. Even the little things that we did made a big difference. There were times when I felt overwhelmed and out of my depth, but those moments would pass thanks to the wonderful team I work with.'
**Joice Joseph, Scrub Nurse.**

'The hospital became a scary place, changes were happening with departments and jobs. My critical care outreach position was no more and ITU nursing became my full time job. The teamwork displayed was exceptional- we were all scared, nervous and uncertain. I had many tears, cwtches (wearing PPE) sad and happy times. The most difficult part for me personally was the fact that our patients were unable to have their loved ones at their bedside... especially during those final moments of life. That I will never forget. The generosity of the general public was overwhelming and for that I will always be grateful.'
**Rhian White, Critical Care Nurse.**

'Overwhelmed.'
**Lyndsey Jones, ITU Nurse.**

## Glenn Dene

Glenn Dene is a South Wales based Operating Department Practitioner, who works for Aneurin Bevan University Health Board. He is also a photographer and writer. In 2017 his documentary photography project 'Magpie' which follows the lives of ten children with ASD was published in fourteen countries. In 2019 he published his first novel *Rotten Apples Comedy Club*. He lives in Abergavenny with his wife, children and labrador.

## Dr Ami Jones

Dr Ami Jones MBE is a South Wales based Consultant in Intensive Care Medicine, Pre-Hospital Emergency Medicine and Anaesthesia who works for Aneurin Bevan University Health Board and EMRTS Cymru / Wales Air Ambulance. She is also a Lieutenant Colonel in the Royal Army Medical Corps and has undertaken two tours of Afghanistan as the medical officer on the Medical Emergency Response Team. In 2017 she was awarded an MBE in the Queen's Birthday Honours for services to military and civilian pre-hospital critical care. She lives in Abergavenny with her partner, child and labrador.

Behind the Mask
Published in Great Britain in 2020 by Graffeg Limited.

Photographs by Glenn Dene copyright © 2020. Written by Ami Jones copyright © 2020. Designed and produced by Graffeg Limited copyright © 2020.

Graffeg Limited, 15 Neptune Court, Vanguard Way, Cardiff, CF24 5PJ, Wales, UK. Tel 01554 824000 www.graffeg.com

Glenn Dene is hereby identified as the author of this work in accordance with section 77 of the Copyrights, Designs and Patents Act 1988.

A CIP Catalogue record for this book is available from the British Library.

ISBN 9781913634872

eBook 9781913634889

1 2 3 4 5 6 7 8 9